Healing Las Vegas

University of Nevada Press | Reno, Nevada 89557 USA
www.unpress.nevada.edu

LIBRARY OF CONGRESS CONTROL NUMBER: 2019905299

ISBN: 9781948908474 (hardcover: alk. paper)
 9781948908481 (ebook)

The paper used in this book meets the requirements of American National Standard for Information Sciences—Permanence of Paper for Printed Library Materials, ANSI/NISO Z39.48-1992 (R2002).

SECOND PRINTING

Manufactured in China

Healing Las Vegas

The Las Vegas Community Healing Garden
in response to the 1 October tragedy

Edited by Stefani Evans and Donna McAleer

UNIVERSITY OF NEVADA PRESS *Reno & Las Vegas*

Notes

Terminology

This book uses the term, "1 October," which the public adopted as the reference to the tragic event that cost fifty-eight lives, changed countless other lives, and became the catalyst for creating the Las Vegas Community Healing Garden.

We also use "October 1, 2017," or "October 1" when we refer to the date on which the event happened.

Location

The Las Vegas Community Healing Garden is located at 1015 South Casino Center Boulevard, Las Vegas, Nevada 89101, just north of the intersection at East Charleston Boulevard.

Dedication

This book was inspired by the people who envisioned, built, planted, tended, decorated, visited, prayed at, and connected around a special place—the Las Vegas Community Healing Garden—honoring those who died at the 1 October shooting in 2017.

People who lost someone they loved and those who survived the event bore witness to what they experienced that day.

You did not have to be at the Route 91 Harvest Festival to be touched by the tragedy. Maybe you stayed awake for hours watching the news, aghast as the death toll climbed from two to twelve to twenty to finally fifty-eight. Or perhaps you called friends—repeatedly—until you finally heard they were home safe. And maybe you were one of the thousands who asked themselves, "What can I do?" or "How can I help?"

These memories were captured in oral histories collected in the months following the tragedy by the Oral History Research Center at UNLV Libraries.

The Las Vegas Community Healing Garden was one response to the question, "How can I help?" The garden, conceived on Monday, October 2, as a sketch on the back of a napkin, was created in just a few days by a multitude of volunteers and local businesses. It was dedicated on Friday, October 6.

Working with the City of Las Vegas, the nonprofit organization Get Outdoors Nevada joined the effort and coordinated an ever-growing band of volunteers to keep the garden going by staying in touch with the families of the deceased and shepherding events held in the garden. The group also had the foresight to chronicle the garden in periodic photographs as it evolved.

This book takes its shape from a quote by one of the men who envisioned the garden, "He who plants a tree plants hope," inspired by Lucy Larcom's nineteenth-century poem, "Plant a Tree." Her insights give structure to this portrait of healing.

How the Las Vegas Community Healing Garden came to be—an organic and spontaneous response to the unthinkable—is collected here in words and images. They tell the story of how our community came together to plant trees and flowers and find comfort. And now, through this book, we share with you how our garden grows: through hope, and love, and joy, and life, and peace.

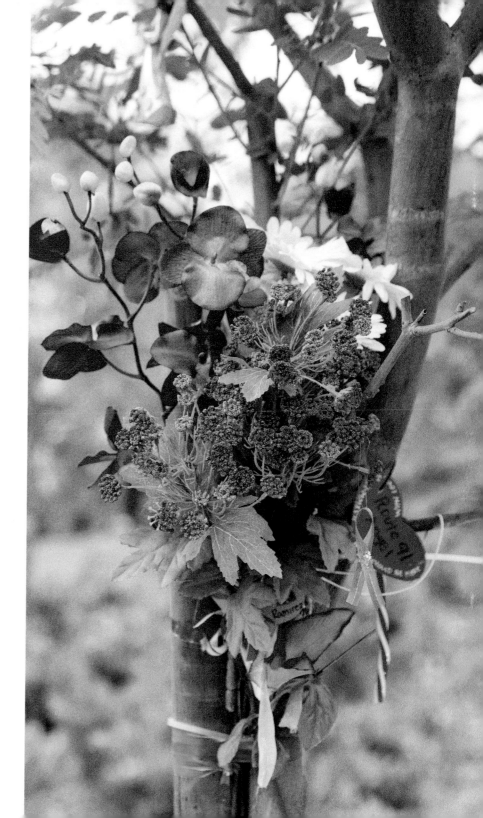

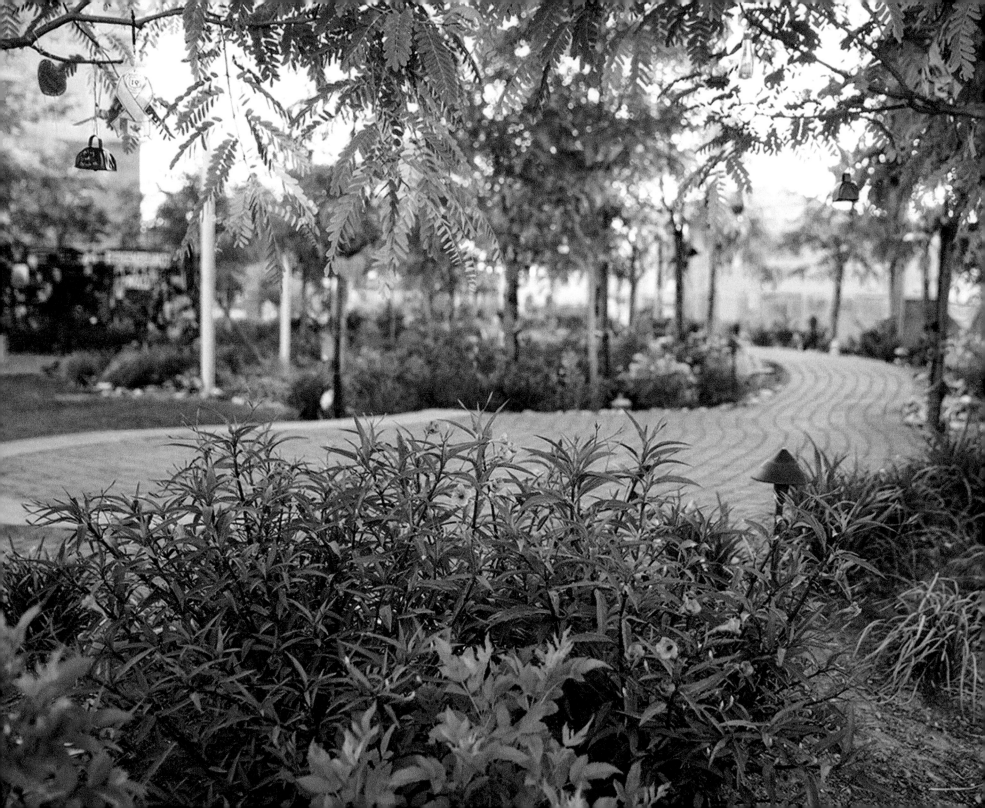

Contents

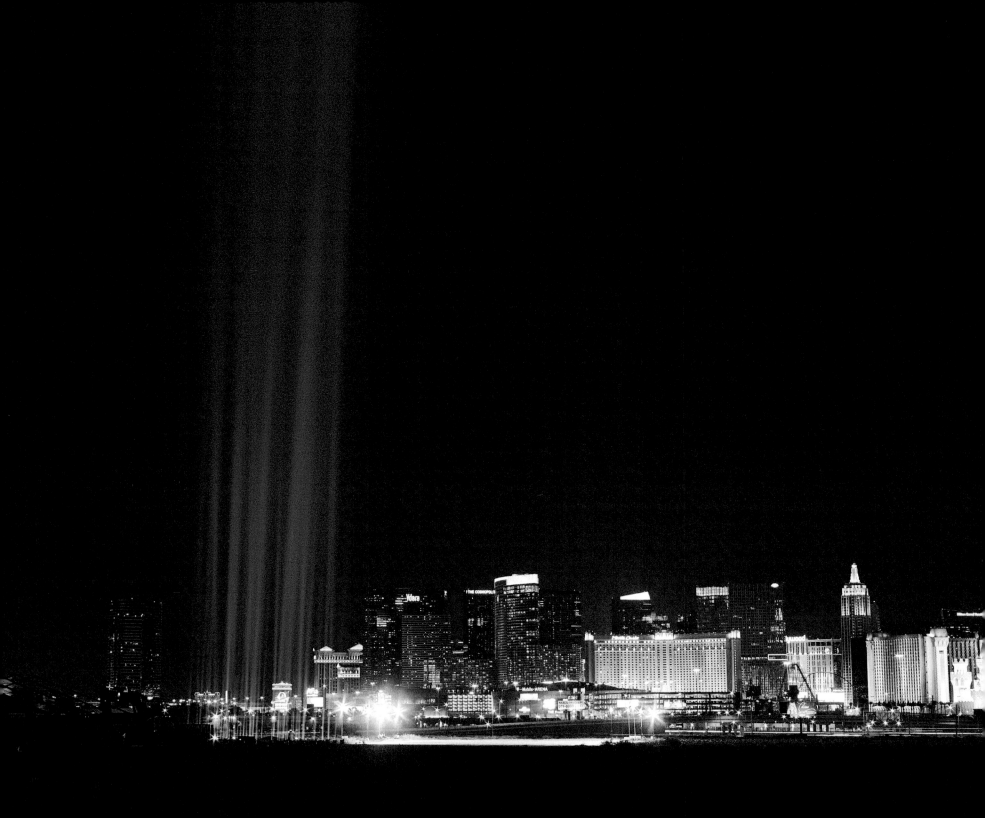

1 October

Late Sunday evening, October 1, 2017 a gunman opened fire on the crowd at the Route 91 Harvest Festival on the Las Vegas Strip. Fifty-eight people were killed, more than 860 were injured, and thousands were psychologically wounded. To date, it is one of the deadliest mass shootings in the U.S.

More than one event happened that day beyond the infamous act of a man shooting into a crowd. There were thousands of events: quiet heroism amid sights and sounds more like a war zone than a concert.

Music lovers ran—anywhere, over any obstacle, helping one another (often strangers)—as they searched for safety. Passersby became paramedics. Pickup trucks became ambulances. First responders navigated chaos to render aid. Doctors and nurses rushed to hospitals to triage the injured and save lives.

Counselors, social workers, and trained trauma volunteers met with the families, the shell-shocked, and the simply shocked to help them process what had happened. Police, architects, hotel employees, UNLV personnel, and community volunteers created safe places to assist with recovery.

As the scope of the tragedy that became known as 1 October emerged, thousands of Las Vegas residents found ways to help—bringing food and water to those affected, offering comfort and care, waiting hours at blood banks.

And by creating a garden—the Las Vegas Community Healing Garden—in just a few short days.

The garden is a place where people can gather, not only to mourn lost lives, but also to celebrate them and to provide a place of calm, compassion, and community to all who struggle with loss.

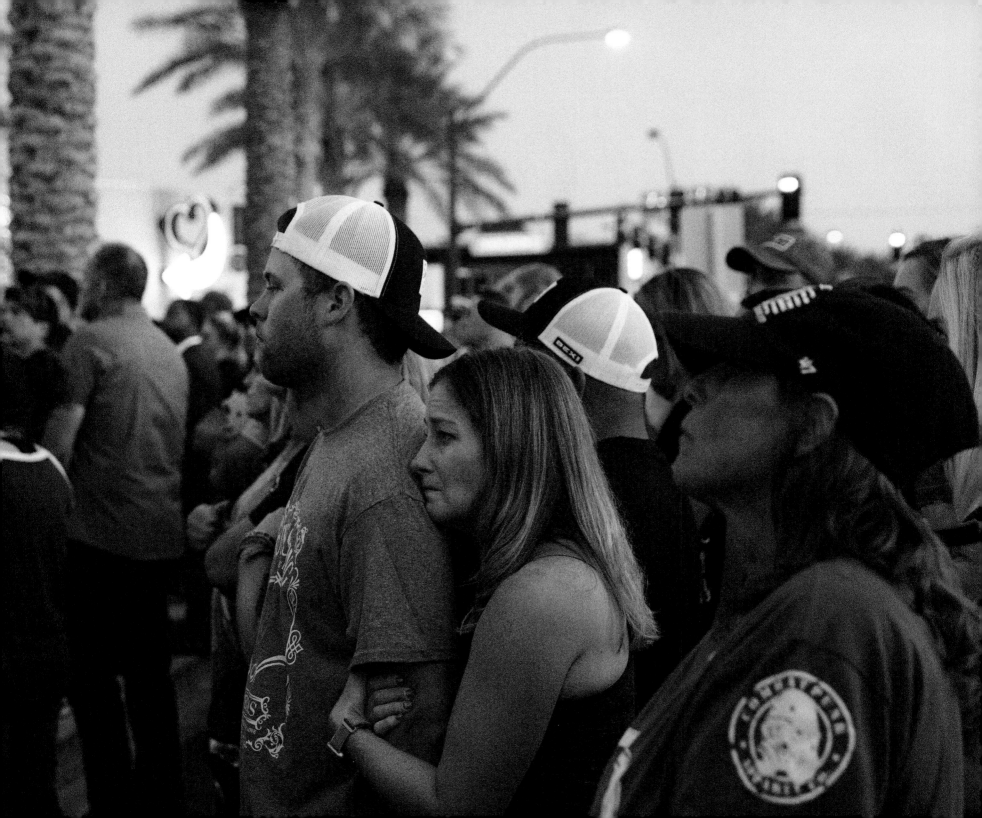

It happens so fast, but so slow. You're kind of waiting to see, *is this really what I think it is?* And you don't want to believe it. You don't want to believe it. *No, it can't be; it's not possible; not us, not me.*

—Greg Phelps, concert attendee

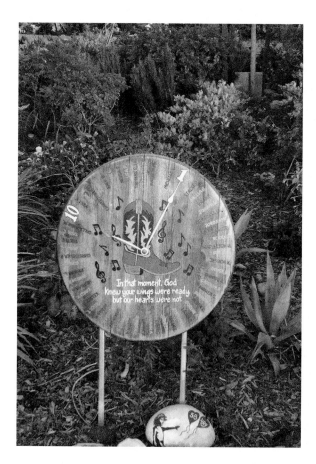

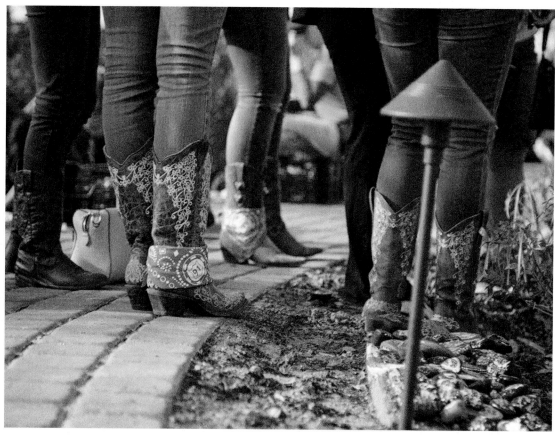

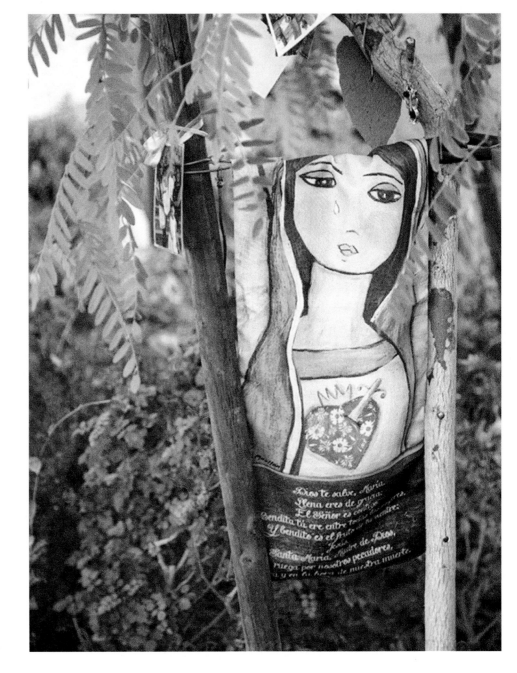

This was an unspeakable tragedy. From this tragic event so much good has come of it, and we've really shown the true character of our city, from the folks that were at the concert to the first responders in the field to all the medical personnel and everybody else in between that stepped up to help people out. We've again met the worst of humanity with the best of humanity.

—Dr. Syed Saquib, trauma surgeon, University Medical Center

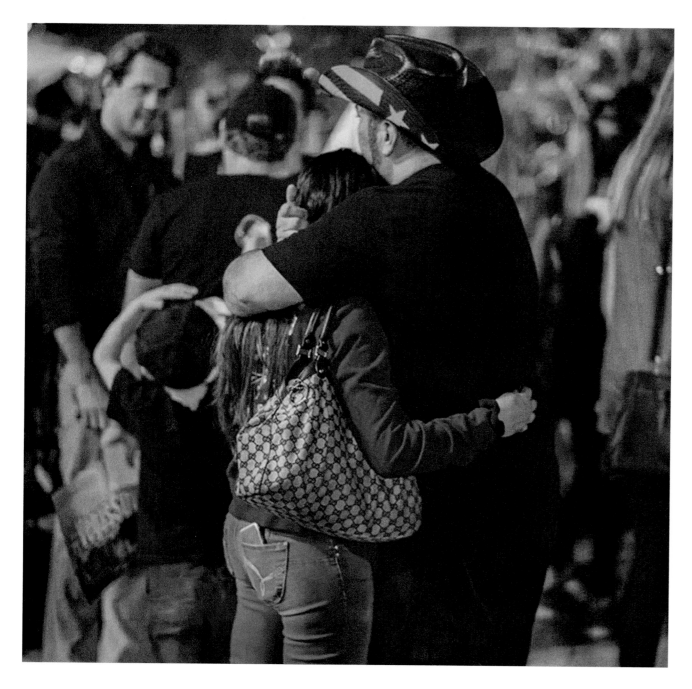

There were acts of heroism which I will never forget. I . . . saw a man lying on top of a woman. Apparently they didn't know each other, but he felt it was his duty to protect her, selflessly.

—David Becker, concert attendee and photojournalist

October 2, 2017

October 1st was a day of tragedy,
But the next day is to be remembered:
The day a community gathered up
And helped a city come together;
Strangers stood up to do what's right
And show that good wins over evil;
The day that everybody stood together,
The day everyone was treated equal;
The day that Sin City died,
The birthday of Vegas Strong;
The day that the city did more right
From the one man who did it wrong;
The day people donated what they can
And gave their blood, sweat, and tears;
The day we stood with those afraid
And helped conquer all their fears;
The day strangers became a family
And who still are to these days;
Where Route 91 went from a festival
To the route that would change our ways.
October 1st is a day to mourn,
The next is a day to celebrate
The day that love conquered evil,
The day that said the hell with hate,
The day a city touched the country
And may its love live longer.
Last year we became Vegas Strong.
Today we're Vegas Stronger.

—Danny Cluff,
concert attendee, October 2, 2018

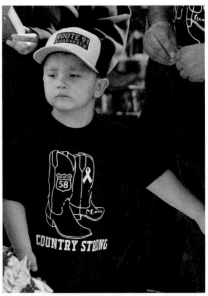

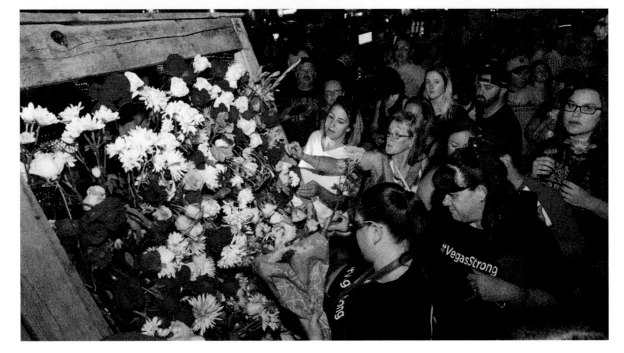

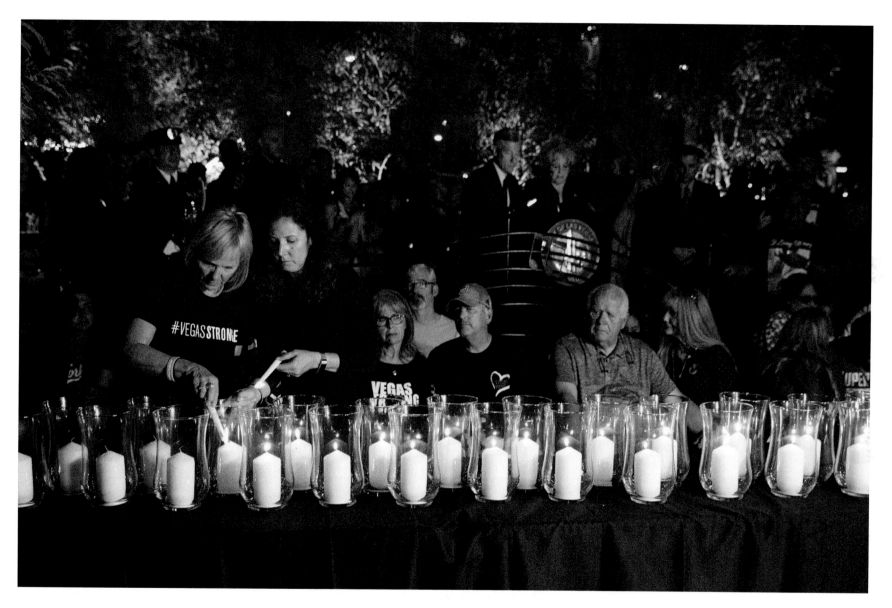

That 1 October Remembrance event [was emotional] with so many family members present. . . .
We lit fifty-eight candles, each one . . . representing a human being.

—Mauricia Baca, executive director, Get Outdoors Nevada

gone but never
forgotten.
evil will not win.
we are
#VegasStrong

Cliff.Aly.Lana&Liam
Blackmore

At the top of the heart, we took all the red tiles and shattered them and then put them all back together, because our heart was shattered. We put it back together, but the pattern of the broken pieces put together is way more interesting than the perfect lines of the squares.

—Jay Pleggenkuhle and Daniel Perez, co-creators,
Las Vegas Community Healing Garden

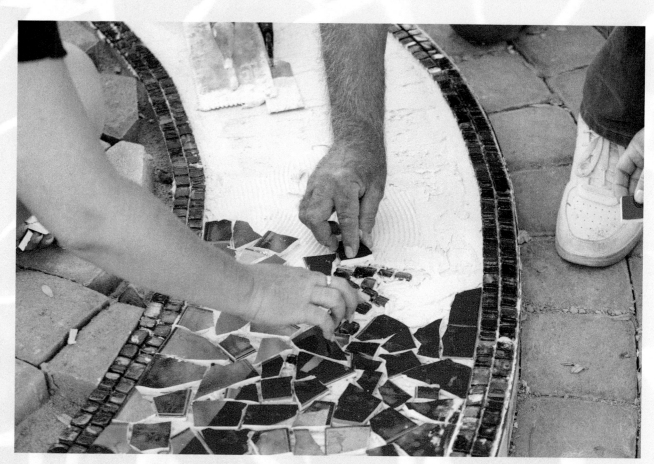

This is where our
story begins

10·1·17

9 1

Founding the Garden

The grief and shock of the mass shooting on October 1 were almost too much to bear. On October 2, the community of Las Vegas woke to a new reality. *Tragedies like this happen to other people . . . to other communities.* This time it was in our backyard. This time it was our turn. This time it was our turn to gather and hold candlelight vigils and comfort each other. This time it was our turn to embrace each other and cry. This time it was our turn to come together as a community and grieve.

But where? This tragedy happened at a resort property. How do people light candles and lay flowers in a casino? How do we join together and share hugs, tears, and stories if we don't have a place? We needed a place to comfort each other and walk through our grief together. We needed a place to join together and help each other heal.

Monday morning, my friend, Daniel Perez, and I met at our usual place to have our morning coffee and go over our projects for the week. The grief in the little coffee shop was palpable. The waitress cried as she told the story of her daughter being at the Route 91 concert. Her daughter's frantic call, "Mom they're shooting at us!" Everyone had a story. We all shared a common hurt. We needed to join together and do something. But what?

I mentioned to Daniel the idea of a pop-up garden. We could borrow a small corner of a parking lot downtown and ask the local nursery to lend us some plants. It would be our place to gather. It would be our place to lay flowers down and light candles. It would be our place to collectively mourn. But the idea seemed ridiculous after I thought about it. "Who are we to step forward and do this?" Daniel's reply was simple, "Who are we not to? If not us, then who?"

We made a call to the city attorney, Brad Jerbic. Brad had lost a dear friend in the shooting and was struggling with unbearable grief. After explaining the idea for a pop-up garden, Brad asked us to come to city hall and elaborate on our idea. Upon arrival, we met Tom Perrigo, executive director of community development.

Tom and Brad embraced the idea. Their only request was that the garden be permanent. Jorge Cervantes, chief operations and development officer for the City of Las Vegas, then located a vacant piece of property in the heart of downtown for the city to give to a grieving community. With that bold action, the Las Vegas Community Healing Garden was born.

The garden was designed on the back of a napkin. In twenty minutes, the design of the garden was channeled through us. A heart became the centerpiece—the heart of our community. A grove of fifty-eight trees formed as a living symbol of the fifty-eight lives lost. A pathway ascended through the grove in quiet meditation and reflection. A remembrance wall appeared—a place to leave notes of things not said to those whose lives were cut short.

With sunrise on Tuesday, a miracle began. People gathered on a dusty lot. Materials and donations started to appear. Together, hundreds of people planted trees and flowers. They built pathways and a remembrance wall. They hugged and cried. They shared their stories and bared their souls. By Friday evening, the miracle had occurred. A crude yet beautiful garden was complete. But even more miraculous than the garden was the presence of love and hope that flowed through it.

The Las Vegas Community Healing Garden is a gift that we have given one another. It is a sacred place for us to come with our brokenness. It is a place to visit to sit in our grief. It is a place to pick up the shattered pieces of our lives. It is a place for us to join together and put these pieces back together with love and compassion.

—All quotes in this section, unless otherwise noted, are provided by Jay Pleggenkuhle, co-creator, Las Vegas Community Healing Garden

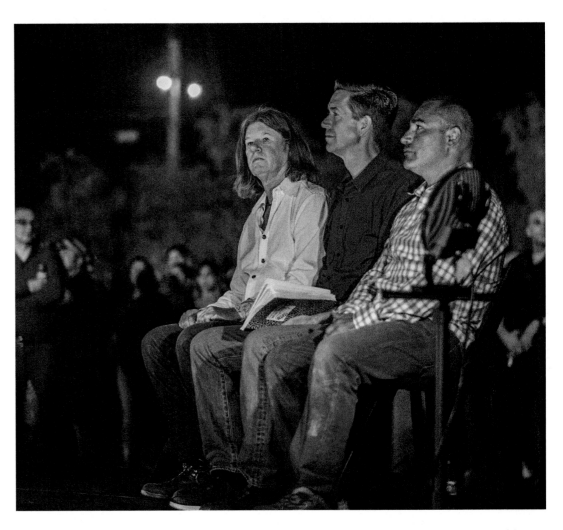

Left to right: Brad Jerbic, Jay Pleggenkuhle, and Daniel Perez.

COMMUNITY HEALING GARDEN
CONCEPT.

WALL OF REMEMBRANCE

TREES
ONE FOR EACH LIFE LOST.

TREE OF LIFE -
TIMELESS

MOULDING FOR
GROVE - ELEVATED
TO HIGHEST PLACE

PATH THROUGH GROVE

PATH THROUGH GROVE

PAVERS

PAVERS

TURF

TURF

"HE WHO PLANTS A TREE
PLANTS HOPE."

HEALING HEART -
COVERED WITH TILES.
MESSAGES. 18" HT FOR
SEATING.

Daniel had scribbled this heart on a napkin and then he was going to wad it up and throw it away. But it looked really cool because he's actually a really good artist. I said, "Don't do that." . . . To me it made sense because it was a heart, and it's in the center of Vegas, and our heart just got shattered. We started with that heart in the center, and then I just started . . . drawing the trees around it. . . . That was our blueprint.

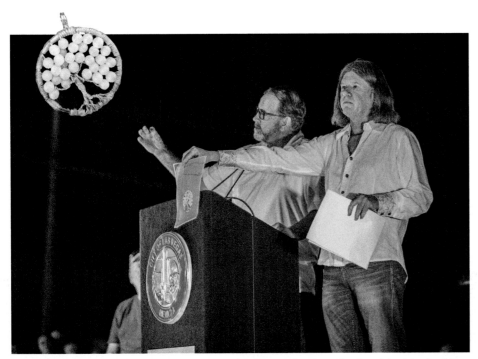

Left, Mark Hamelmann (holding Tree of Life pendant); right Brad Jerbic (holding photograph)

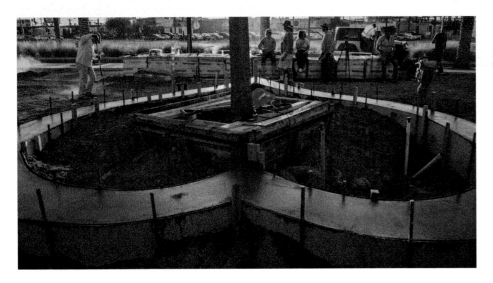

A Tree That Was Meant To Be

The morning of Monday, October 2, 2017, began with the most horrifying news anyone could receive. A dear friend and coworker along with fifty-seven other souls had been shot and killed. As we struggled to accept this unbearable news, the city received a call from Jay Pleggenkuhle, who wanted to create a place where our community could begin to heal. Jay wanted to spend the week building a healing garden and asked if the city had any available property for this project.

That same day, the city found public property for the garden in downtown Las Vegas, and Jay provided the design for a garden that would include one tree for each victim—and one more tree that would be at the heart of the garden, which he called the Tree of Life

On Tuesday, Mark Hamelmann, a private citizen and a quiet man with a caring heart, answered the call to help create this garden. He went out to identify and mark the location for the trees and features in the garden. He spotted a location he thought would make a good place for the heart of the garden where he could place the Tree of Life. Mark went to that spot and began to kick around in the dirt to check the consistency of the soil. As he lifted his boot, he found a small gold chain clinging to the tip of his boot. As Mark reached down to remove the gold chain from the ground, he was stunned to find a medallion attached to the chain. As he cleaned the medallion, he came to find what appeared to be a tree trunk and limbs. The medallion was crafted in the image of a tree. Not just any tree—the Tree of Life.

—Brad Jerbic, Las Vegas City attorney

Heart Boulder

In the middle of the chaos of building the Healing Garden, a truck pulled up. The back of the truck was heavily weighted. A couple got out. Their faces looked pained. They came with a gift they wished to give to the city.

In the back of the truck was a large granite boulder shaped like a heart. It was clear that this boulder had a special meaning to this couple.

This heart boulder was a well-thought-out Christmas gift from a husband to his wife, whom he loved and cherished. It was the centerpiece of their garden. This granite heart was part of their life and their ritual. Each morning they started their day sharing coffee and conversation by the heart boulder in their garden. It brought them together to start each day.

They came to the garden to offer their heart. They said the city needed it now more than they did. Together we picked out a spot in the Healing Garden for the heart boulder. Placing the boulder felt sacred. Tears flowed.

As the couple drove away, it was amazingly clear that the heart boulder was the most precious stone this man had ever given the woman he loved—more precious than any diamond.

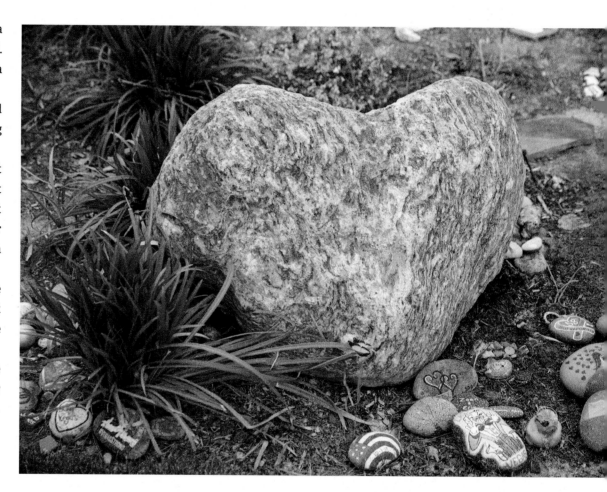

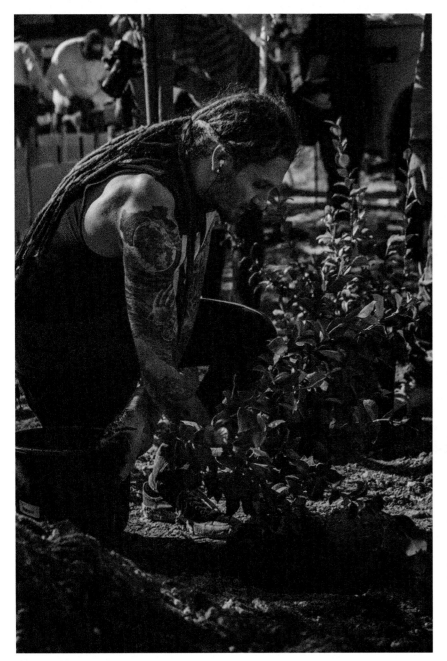

We had college kids, young kids, my own kids, [Jay's] kids.
It was great having everybody there. It was really good.

—Daniel Perez

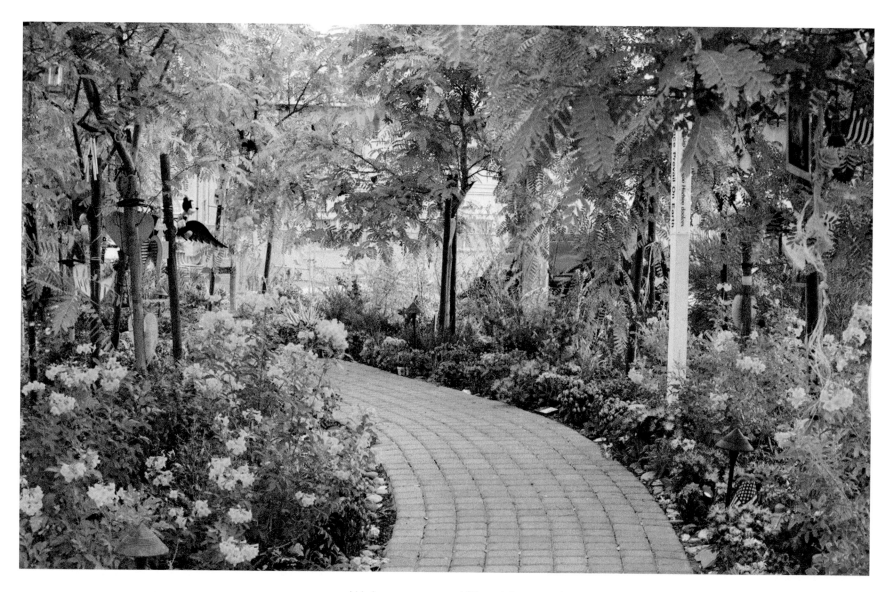

We knew we wanted fifty-eight trees along a walk to create a grove where people could wander through. Because I believe when you're in a grove of trees there's a certain energy from plants. If you go into a forest, especially in an old-growth forest, it's palpable to feel that energy.

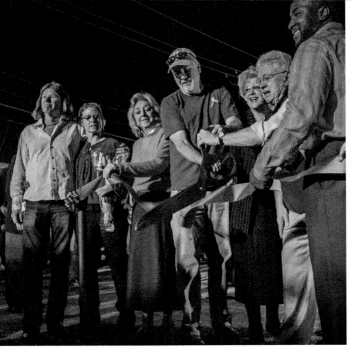

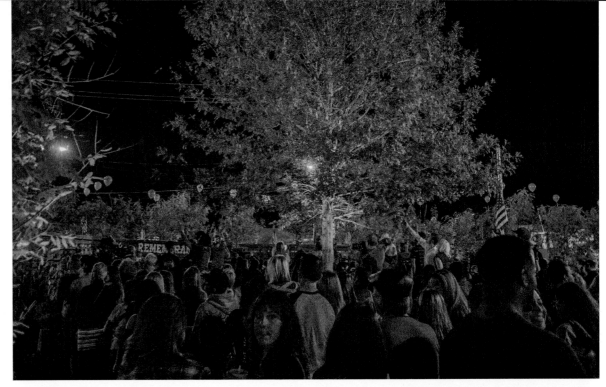

Dedication, Friday, October 6, 2017
Left to right: City Attorney Brad Jerbic; Diane Bradley, bereaved mother; U.S. Representative Dina Titus; and City of Las Vegas officials: Tom Perrigo, executive director, community development; Mayor Carolyn Goodman; and councilmen Bob Coffin and Ricki Barlow.

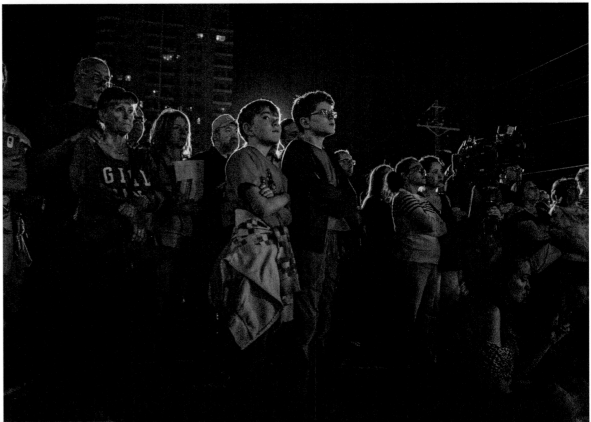

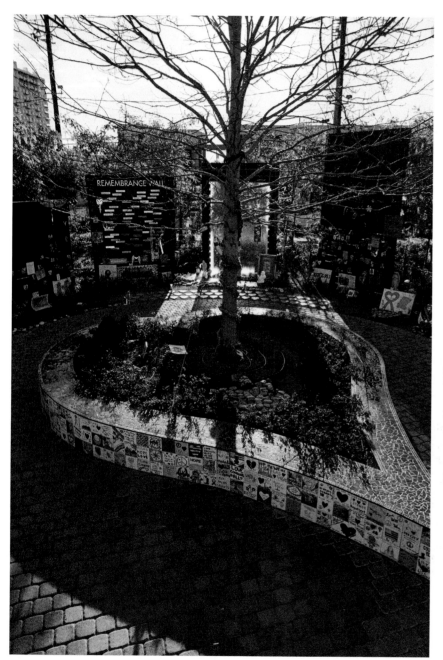

In the Garden

When it is done and the leaves have fallen, hear the whisper of God. . . .
Know this is not the end.
This is a season, a time of rest.
It is a time to reflect on the business of our lives.
It is a time to release what is no longer useful.
It is a time to realize the beauty of all that remains.
Let the memories nourish our souls with sweet sadness and laughter.
Look up to the empty branches of the tree and realize the beauty to come.
Hear the whisper of God.

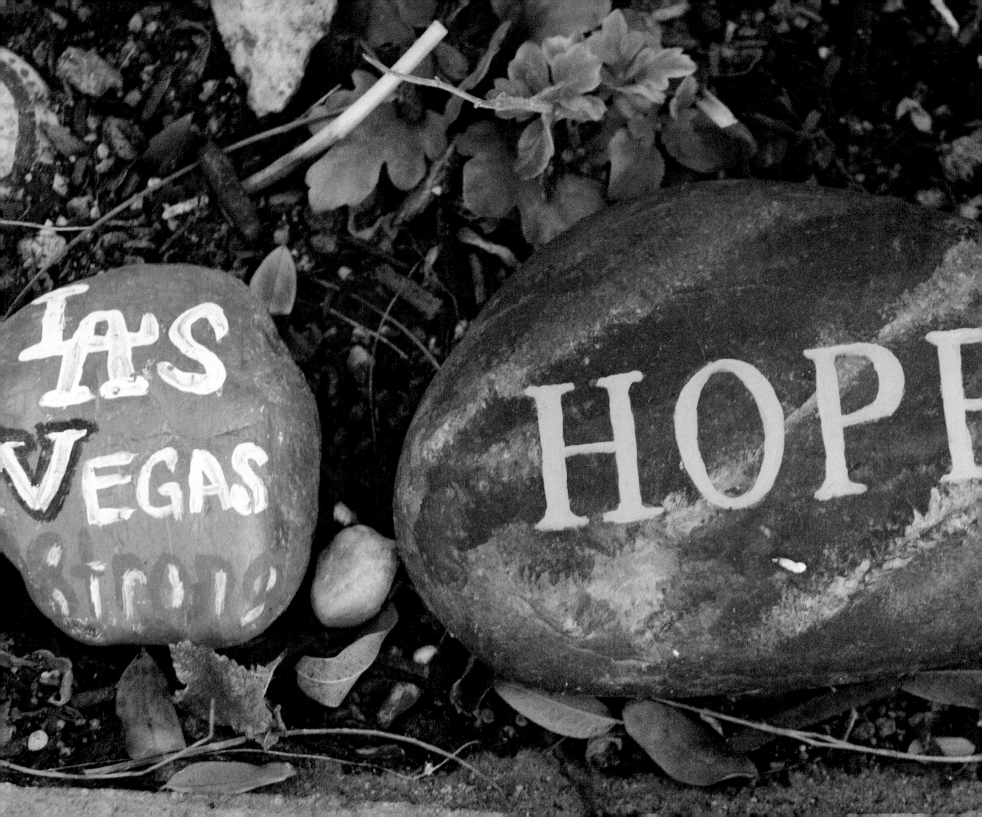

Hope

I am your neighbor. I am your friend. I am the stranger you will come to know.

I am alive—I love. I think. I feel. I see the tomorrow that is here today.

I find silly things to be sacred. These trivial items state my presence and honor your existence.

I long to be the source of strength and present in the making of memories to come. In a fleeting moment, I offer you space and invite you in.

To let you exist in me offers a promise for the future. You will not fade away or be forgotten. You are loved. You are remembered by those who move beyond the tragedy, one day at a time, one story at a time.

I exist so that you may heal. And though I am sometimes lost, I am a breath away—wishing to illuminate the darkness and reveal the path toward future joy.

I am hope.

I am the magic in moments when nothing else will do. It is with me that humanity sustains itself and breathes life into a greater narrative.

I invite you into my Healing Garden. This space where one can forget, one can remember, and one can heal. This space where one is wrapped in the Hope of Future Memories.

—Barbara Tabach, oral historian,
Oral History Research Center,
UNLV Libraries

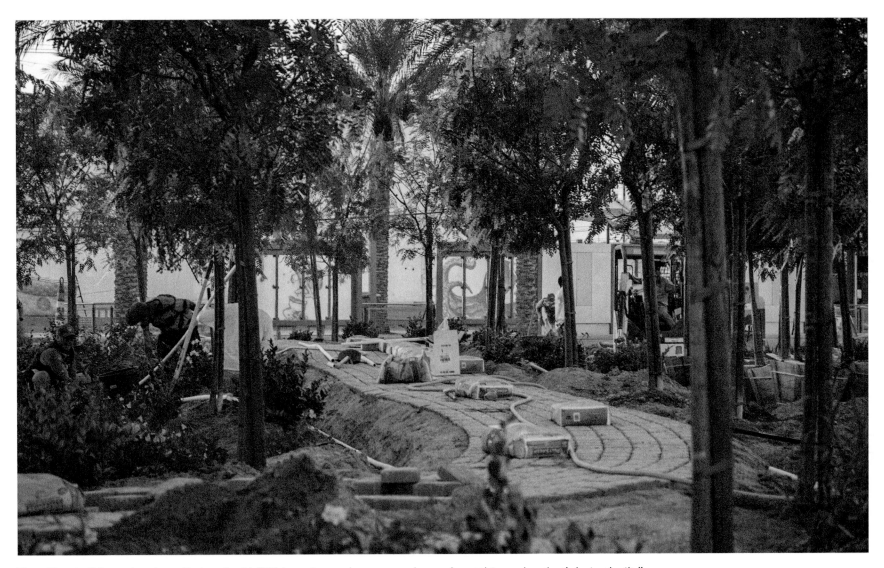

Tom [Perrigo] from the city called and said, "We're going to do a press release about this garden that's being built." He asked, "You're really going to build it by Friday?" That was the only time I really stopped and started thinking, *well, we need trees; we need plants; we need soil, and this should be like a six- or eight-month project.* I thought about it and then I looked around and saw everybody, and I just pushed it down. I said, "Yes, it will happen. It may not be perfect, but it will be a garden." —Jay Pleggenkuhle, co-creator, Las Vegas Community Healing Garden

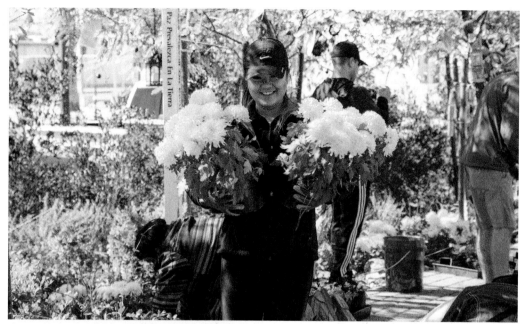

It means a lot to the people who have taken pride in [the Healing Garden]. I believe that's what we should all be doing every day. If we can show that kind of love—pay it forward—man, we'd be a great, great world.

—Daniel Perez, co-creator,
Las Vegas Community Healing Garden

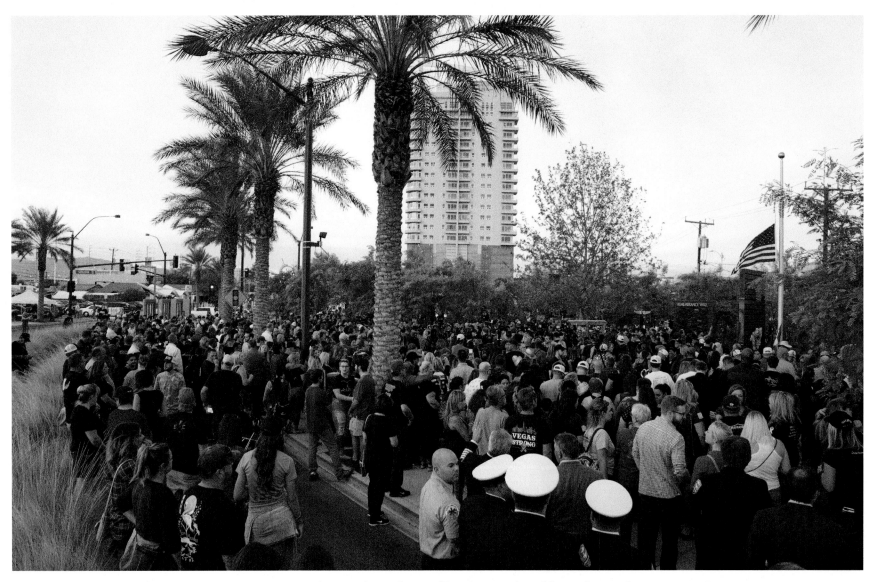

A group called Fifty-eight Acts of Kindness has over six thousand members . . . "In memory of our fifty-eight angels, fifty-eight random acts of kindness." Those are just little things that we're doing, like paying the Starbucks' bill behind us, little things like that. Everybody is doing little things, but the thing is when they do it, it's for the fifty-eight."

—Kimberly and William King, **concert attendees**

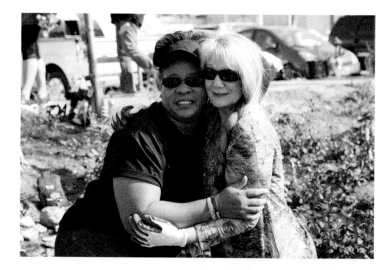

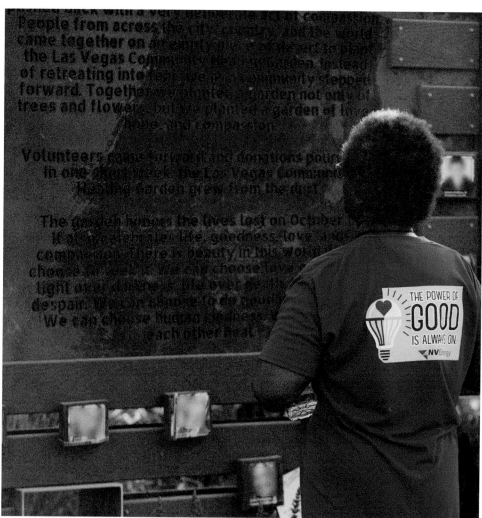

I always loved Vegas because I always thought it's a small city and we're a very close community. But that day I learned how selfless the people that surround us are; they just want to help. . . . Sometimes we see people in crisis and we think that nobody is there to help us or help them, but there are people who are always willing to help. That's one of the greatest things. . . . It's just wonderful that when people are suffering there are always people there that have that attitude to help without regard.

—Aracely Rascon, designer, Vegas Strong Resiliency Center

My thought is go to Washington, D.C., and find a piece of property . . . and create a national healing garden. In doing the national healing garden, I'd like to bring kids from all across the country in buses to build it, volunteers, everything volunteered again. What we do with the national healing garden is we go all the way back to Columbine High School (Littleton, Colorado) and we honor all those people who have lost their lives.

—Jay Pleggenkuhle, co-creator, Las Vegas Community Healing Garden

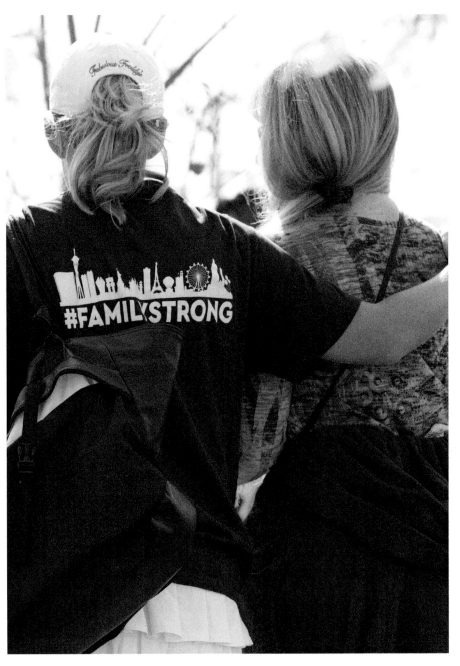

That is the beauty of it; humans heal.... You know from your experience that people heal, and some more than others. People are very different. But people heal. Communities heal.... This is what we hope to bring.

—Talia Levanon, director,
Israel Trauma Coalition

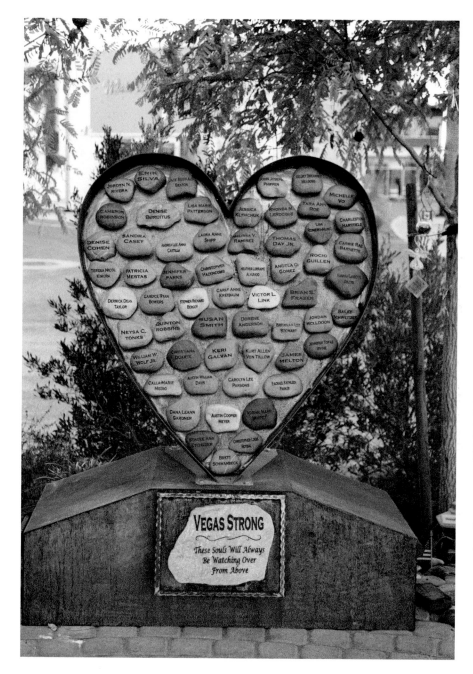

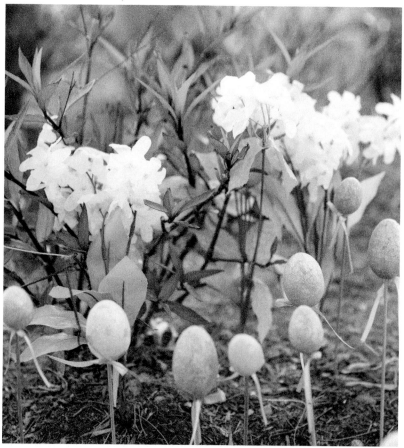

I really like the concept of the Healing Garden because to me healing is hope. A place for people to heal is good. . . . Everyone along the way—taxi drivers, gas station employees, people in restaurants—[the shooting] affected everyone. It was a pebble in a pond, and the ripples were far-reaching, and they're still going. It is still going.

—Zoe Albright, coordinator,
Southern Nevada chapter,
American Red Cross

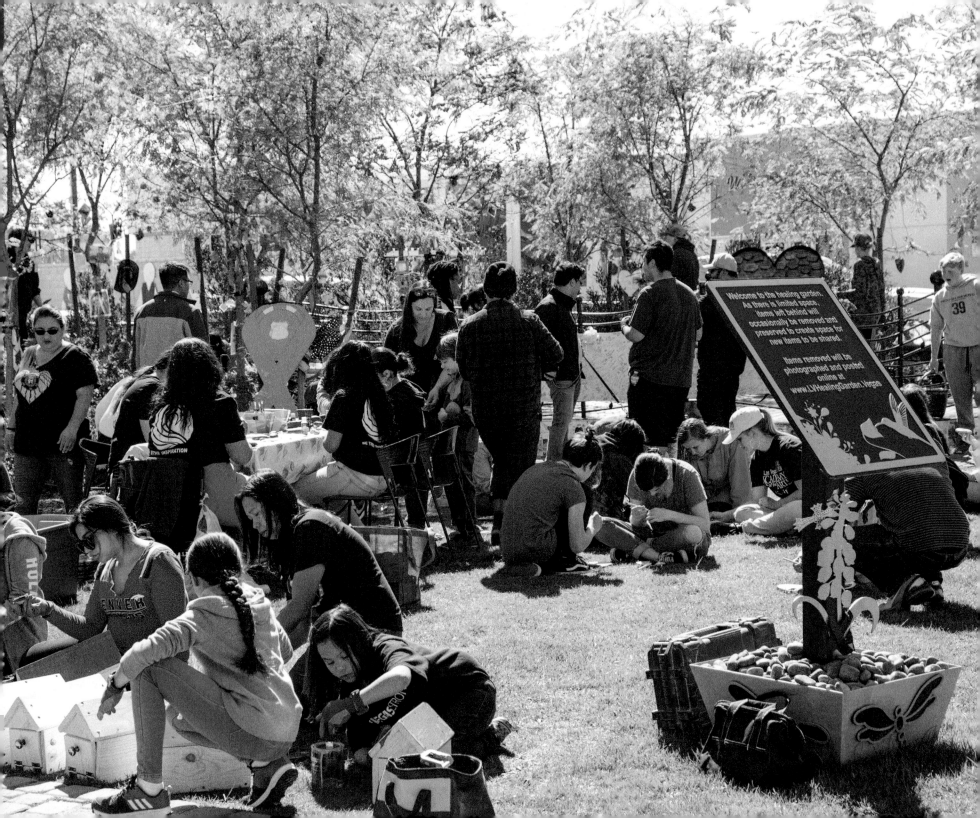

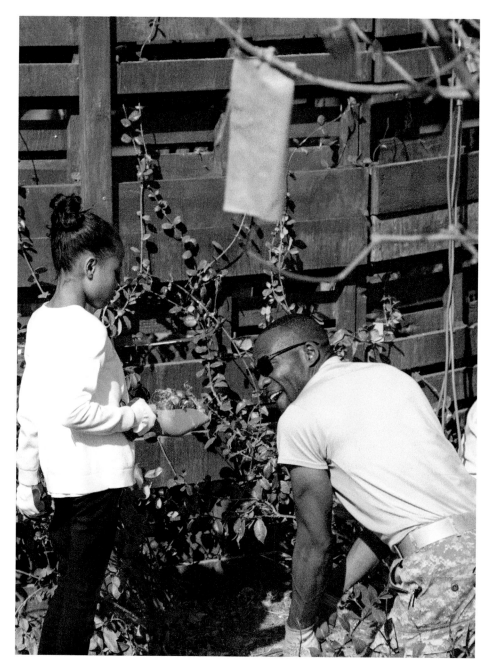

Where there's hope, there's life. It fills us with fresh courage and makes us strong again.

—Anne Frank

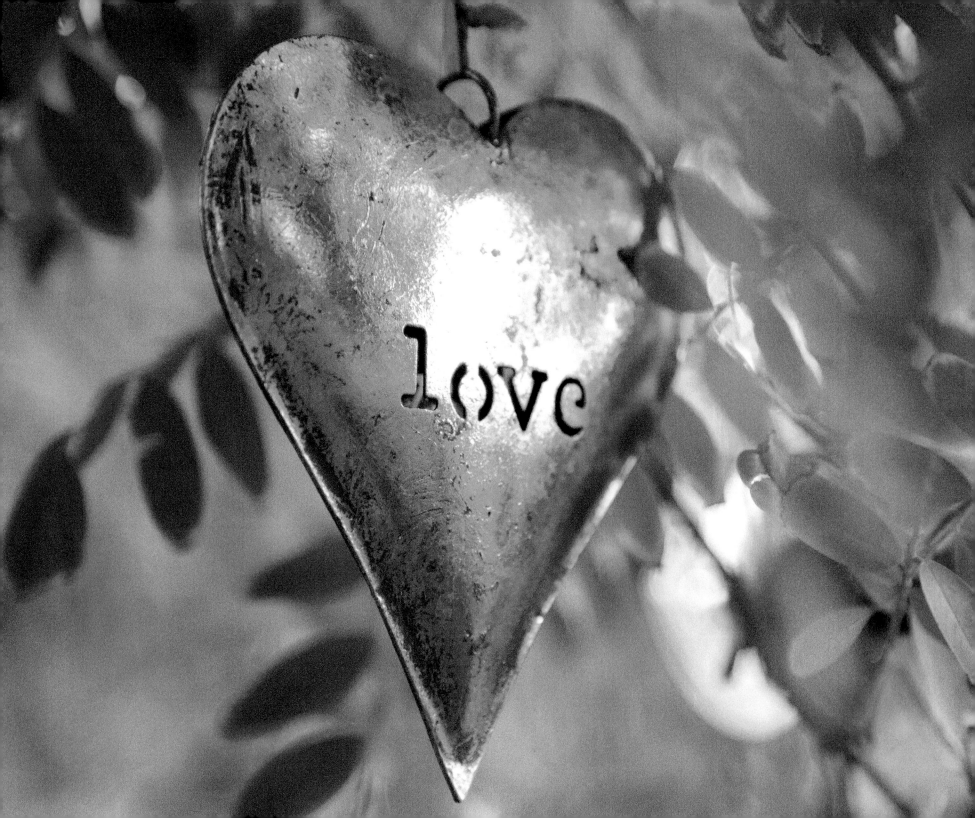

Love

Love is a verb, a word of action. Las Vegans demonstrated love by taking strangers to hospitals; sheltering guests they didn't know; giving blood; sharing blankets, water, pizzas, and cookies; making telephone calls to report good and bad news, and hugging people without introduction. Friendships and partnerships formed. Residents created a Healing Garden in less than five days, and the Vegas Strong Resiliency Center continues to help those affected by the shooting.

Love is a healing balm that flowed over the city. Las Vegans forgot about themselves and made the wants and needs of strangers the supreme goal. No longer transient, we met neighbors for the first time and then united to help visitors. We paid it forward without thinking about what we would receive in return. The giving became paramount.

Love uplifts the consciousness of all humanity. When visitors and volunteers walk into the Healing Garden, the name of the place is made manifest. Healing is possible.

Love is commitment. Las Vegas worked passionately to nurture the world. Our client base—now our friendship base—is truly global. We all collaborated to make the world a better place for everyone. For a time, there was no "us" and "them." There was just us—all of us as one.

Love is blind, without judgment. After 1 October, Las Vegans reached out to the next place of tragedy. Parents, police officers, coroners, doctors, and siblings formed media outreach networks to help the next city, and the next. We learned to love and give and pay it forward.

Love is strong. It lifts, cradles, and nurtures. Love is Vegas Strong.

—Claytee D. White, director,
Oral History Research Center,
UNLV Libraries

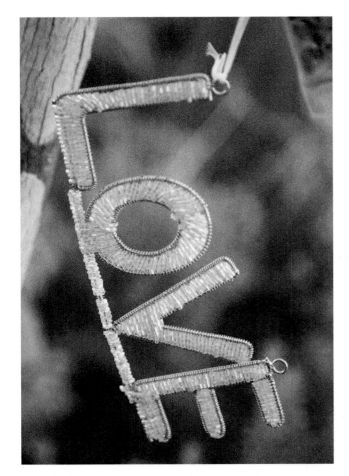

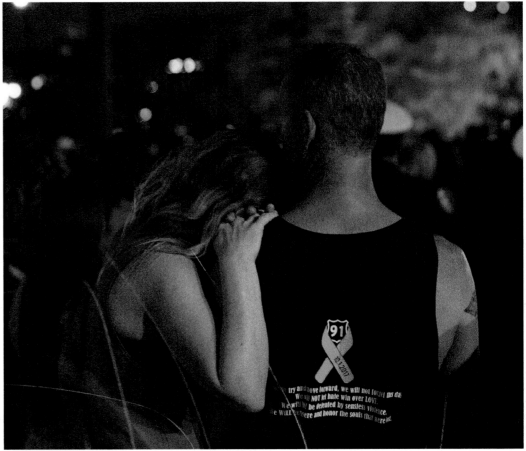

I was talking about the incident from the time I woke up in that hospital bed after surgery . . . and I think that has helped me a lot with it. I didn't keep anything in. I literally have no problem telling anybody about it without getting emotional or anything like that. I think the repetitiveness of it . . . makes us say, *okay, this actually happened. I made it through it.* I think some people just hold it in too much, and they don't want to talk about it. They don't even want to think about it. . . . But it was an event that actually happened, and you have to sometimes relive it to . . . realize you went through it; you survived. Now, what are you doing to help yourself and help others? That's what I've come out with: *how can we help each other?*

—Nick Robone, concert attendee, UNLV assistant hockey coach

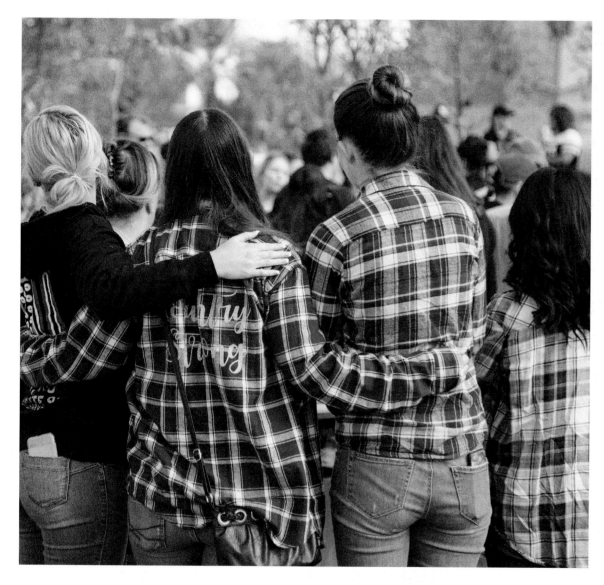

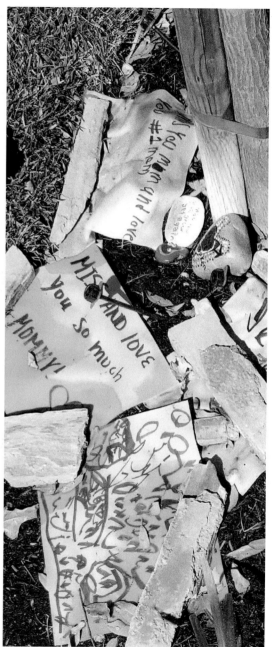

They just want to do something.... What you have to realize is no matter where you live, it's their hometown; they want to be part of the solution. They want to have some type of connection.... *I dropped off food; I made a plate of lasagna; I bought a case of water; I donated a refrigerator; I washed police cars.*

—Deputy Chief Andrew Walsh, Las Vegas Metropolitan Police Department

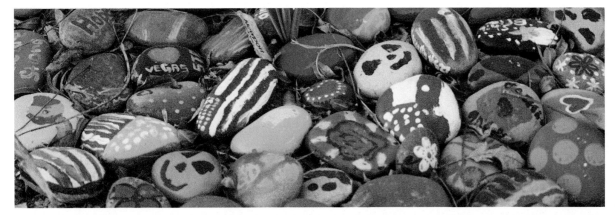

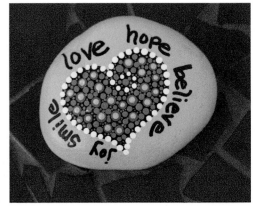

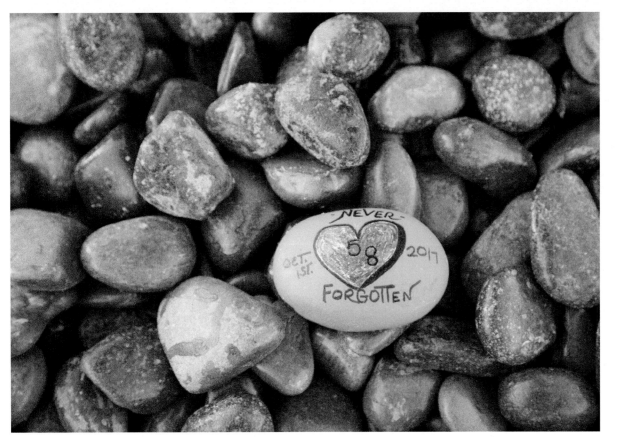

In Jewish tradition, when someone dies it's dust to dust, earth to earth. We believe that we don't leave flowers because the flowers are temporary and they'll just go away. But a stone is pretty permanent, and it's also symbolic of dust to dust. When we leave a stone behind, it's a statement of saying someone was there; someone visited; someone cares. Whatever money was going to be spent on the flowers, we're supposed to give it to charity. The stone is really an ancient Jewish custom of saying a loved one came by to visit and pay their respect.

—Rabbi Sanford Akselrad,
Congregation Ner Tamid

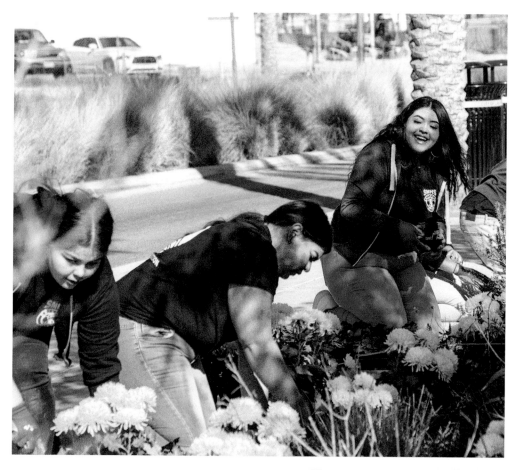

These parents showed up the day before we did the daffodils. . . . They text me quite a bit about what all this means to them and their healing. . . . Here's her comment about the garden: "Oh, Jay, we were so honored to meet you and participate in the tulip bulb planting. We never expected to find anything but heartache coming back to Vegas, but in the garden we found peace and comfort and we made lifelong friends. . . . When people ask what they can do for us, I usually say nothing; your prayers, love, and support are all we need. But now I talk about the garden . . . so they can contribute to this beautiful, beautiful peaceful place that you've created for us all to come together and find comfort. We are forever grateful."

— Jay Pleggenkuhle, co-creator, Las Vegas Community Healing Garden

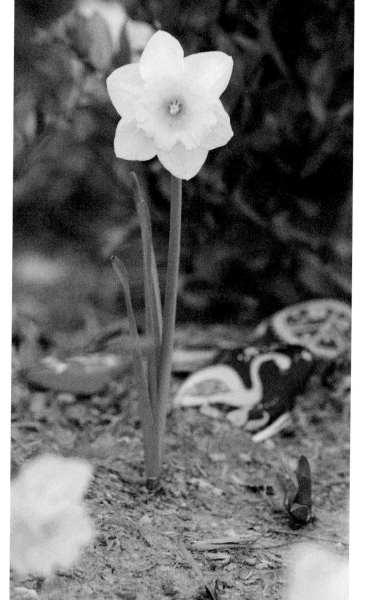

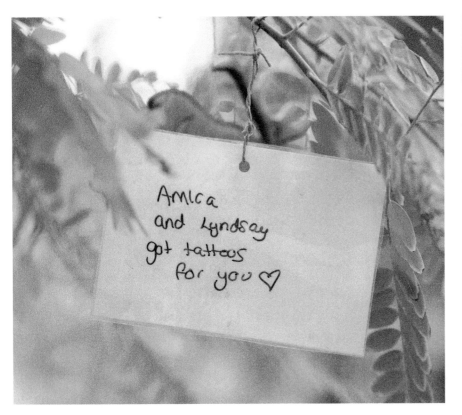

> Those we love
> Don't go away,
> They walk besides us
> Every day,
> Unseen, unheard,
> But always near,
> So loved, so missed,
> So very dear...

A friend of mine . . . is a graphic design artist. She helped plant and do the Healing Garden. . . . She's going to . . . work on a tattoo for me, a design. I don't ever want to forget it. . . . I want to get past it, but, at the same time, I don't ever want to forget what has gone on. —Corey Nyman, concert attendee, restaurateur

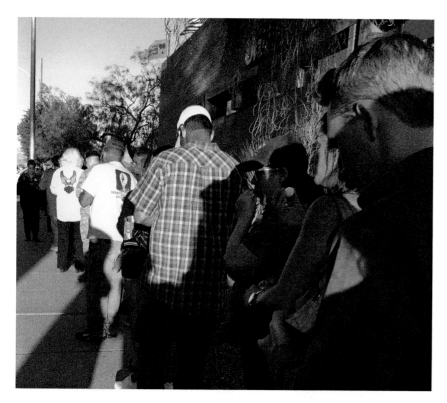

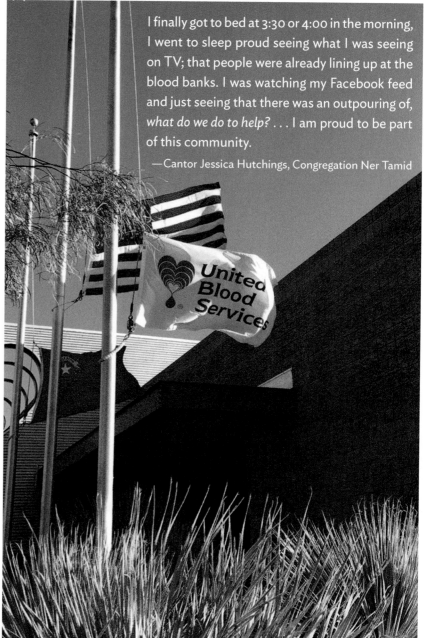

I finally got to bed at 3:30 or 4:00 in the morning, I went to sleep proud seeing what I was seeing on TV; that people were already lining up at the blood banks. I was watching my Facebook feed and just seeing that there was an outpouring of, *what do we do to help?* . . . I am proud to be part of this community.

—Cantor Jessica Hutchings, Congregation Ner Tamid

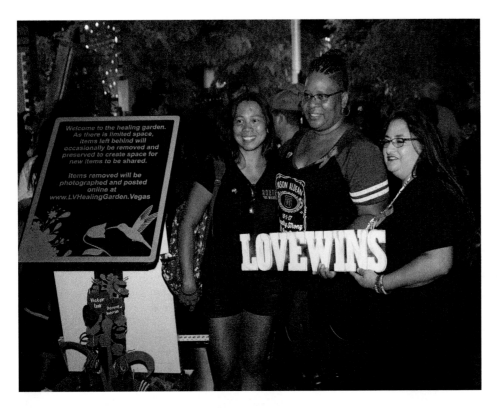

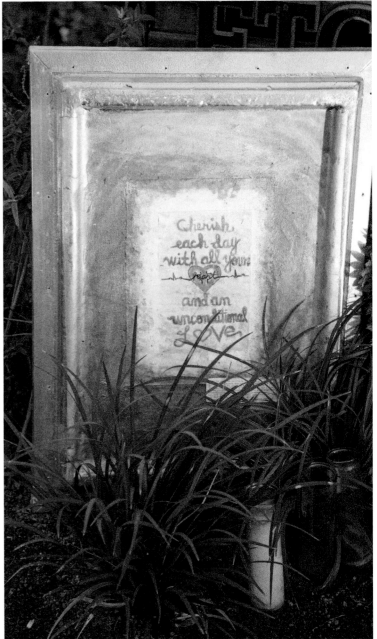

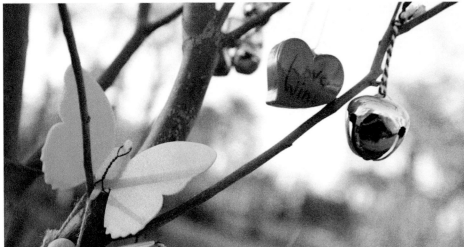

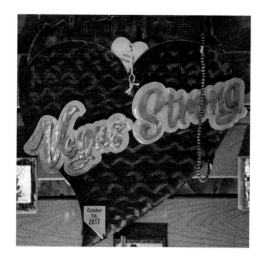

It takes courage to love, but pain
through love is the purifying fire
which those who love generously know.

—Eleanor Roosevelt

How do I love thee?
Let me count the ways.

—Elizabeth Barrett Browning

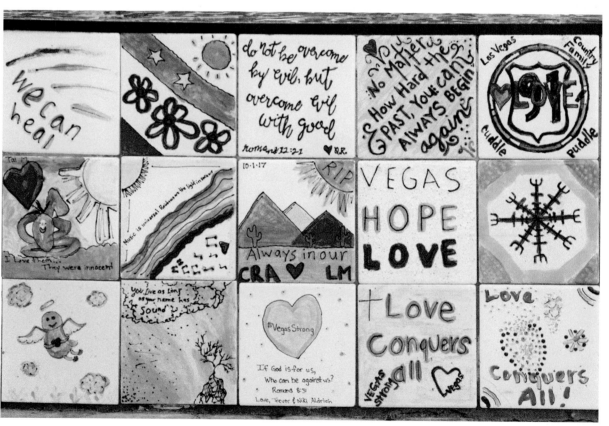

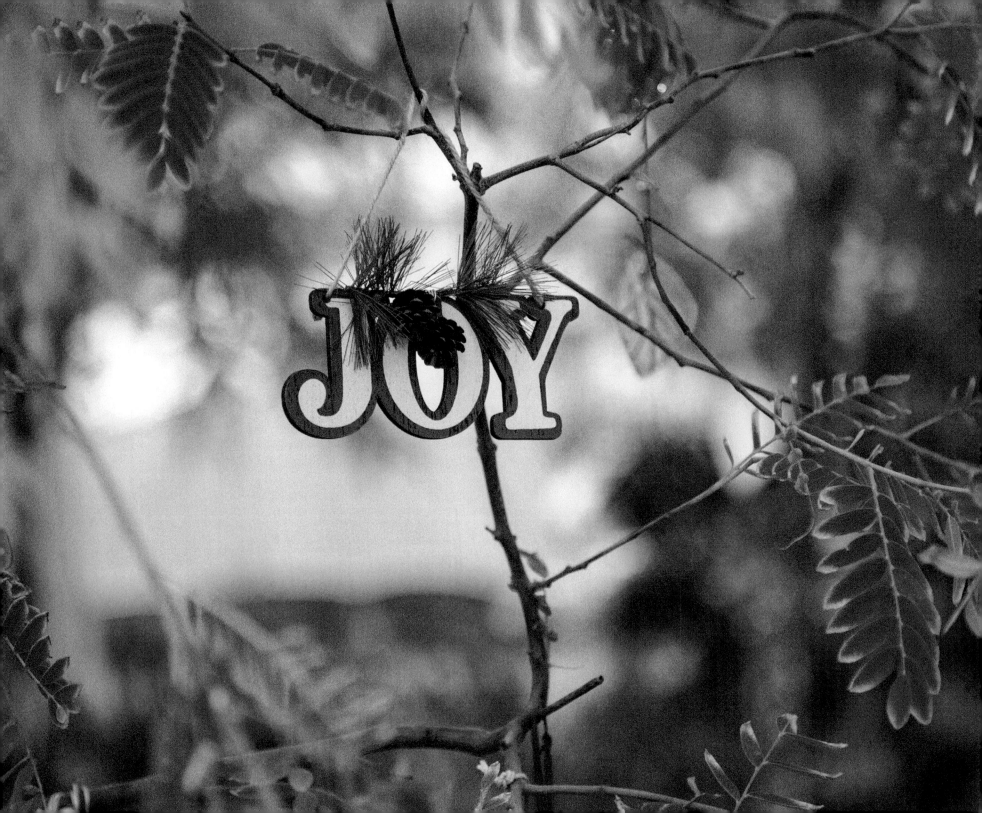

Joy

You would scarcely expect to find joy in the aftermath of the 1 October tragedy. Yet there it is, right in the garden.

It's in the thousands of daffodils that bloom in the spring and chrysanthemums planted in the fall. It's in the tipu trees lovingly decorated by family and friends. It's the words of encouragement and remembrance painted on the rocks and tiles left behind. It's paved into the walkways. It's in the candles lit in tribute and the voices raised in song.

Joy is in the purpose of the people who found some way to say they care, who connected to others, who worked together to celebrate the love they saw and felt when remembering lives inexplicably cut short. Joy is strength in the face of tragedy. It is in resilience defying heartache. It is in the reaching out to others, finding a shared goal despite individual sadness.

Joy is in the smiles of the volunteers, in the labors of love that brought the garden into riotous color, in children discovering they can make something grow.

Joy is reflection. It is something deeper than happiness. It comes from within, and it can live right next to, right in the same space as sorrow, because it recognizes in the moment, in the bloom, something as true, as beautiful, as eternal as the act of caring. It's choosing to believe, despite senseless evil, in hope, in life, in peace.

Mother Teresa once said, "Where there is love, there is joy." And there it is—right in the garden.

—Donna McAleer,
director of publications emerita,
UNLV

When I learned about the Healing Garden, as soon as I learned about it, I went down there, and I shoveled, and I planted, and I laid tiles. There was nowhere else for me to be. It was a strange week trying to juggle a little bit of work—a lot of work, I should say—and knowing that no matter how tired I was, I had to show up in these other spots.

—Lauren Meredith Brown, designer

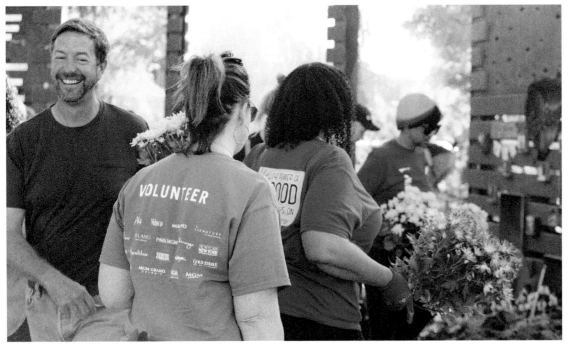

We just wanted to do something to stay busy, something positive, and gardening is a positive thing; it's growing something.

—Jay Pleggenkuhle, co-creator,
Las Vegas Community Healing Garden

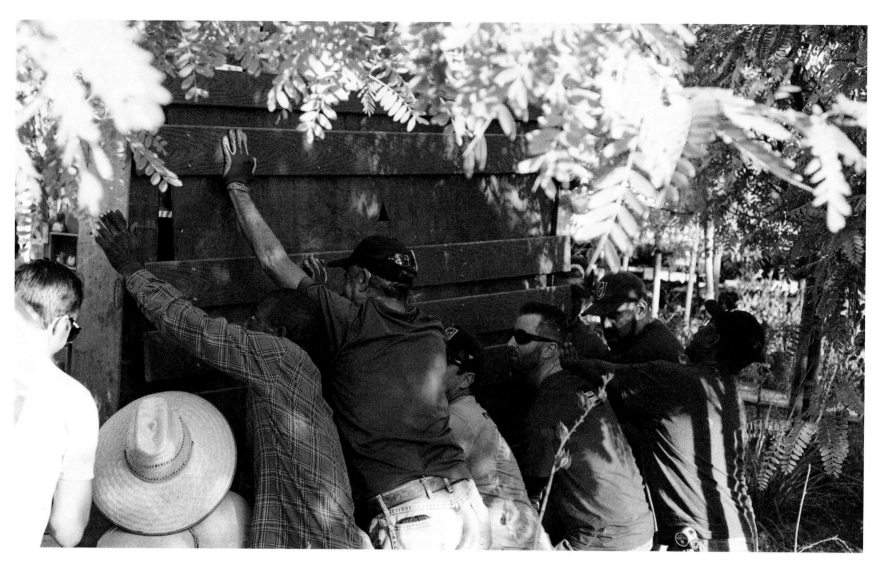

To see so many people, the whole community really, coming together, building that garden and the sign . . . and opening up their homes for families. . . . Everybody came together. It really showed how we have great humanity here. People talk about the city in a much different way. If there was anything good that came out of it, it was showing that we have great people here.

—Laura Sussman, director, funeral and cremation services

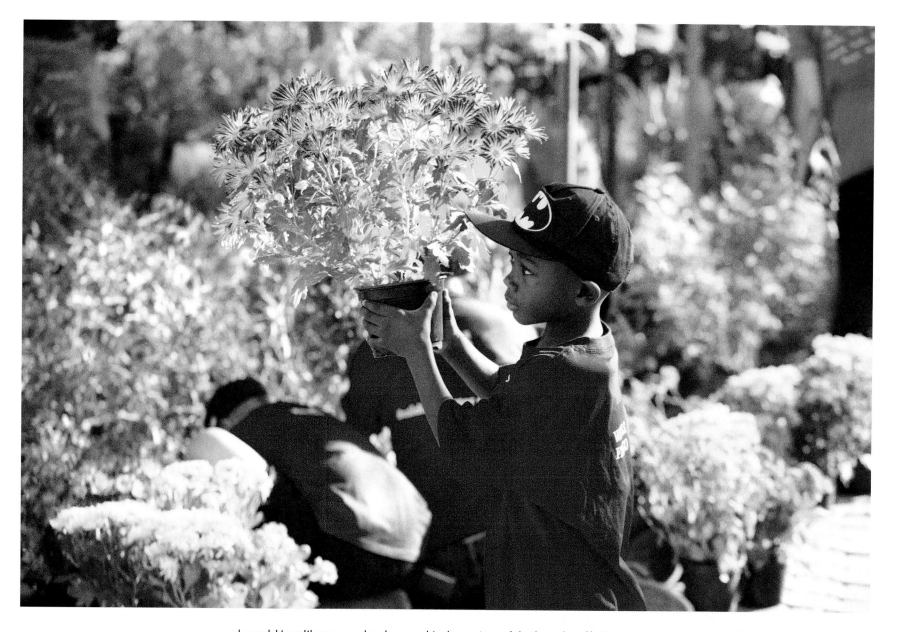

I would just like to say that human kindness, it can't be bought off eBay or a Walmart shelf; it lies within everybody....
The smallest of things could be the greatest thing to a person.

—Andre King, garden volunteer

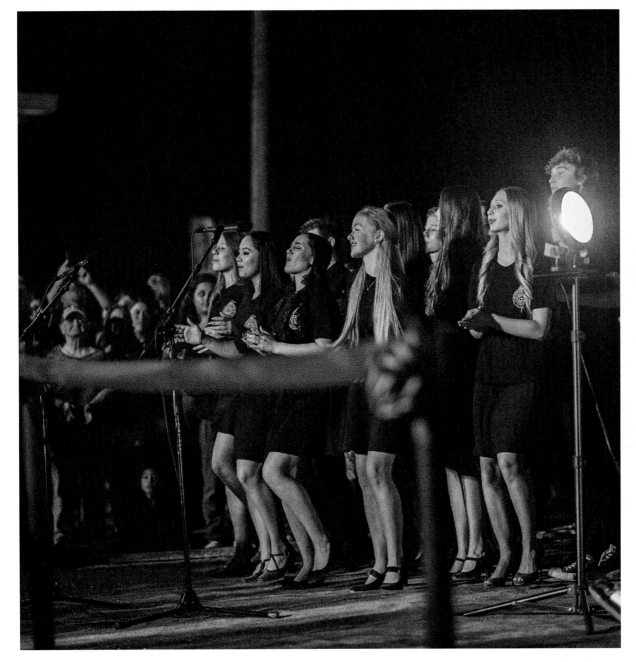

Since 1 October, it's totally changed my perspective about Vegas. . . . The way that I've seen the community just come together. It just showed that everything is different. It's not just the Strip. There's actually families and the way that they've all come together to help out. . . . Everybody just came together. It didn't matter what it was. . . . I definitely want to raise my kids around these people.

—Kimberly King, concert attendee

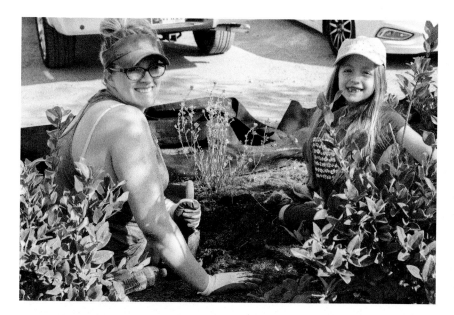

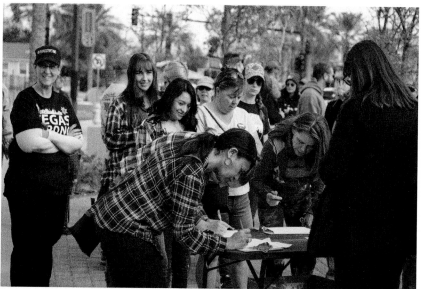

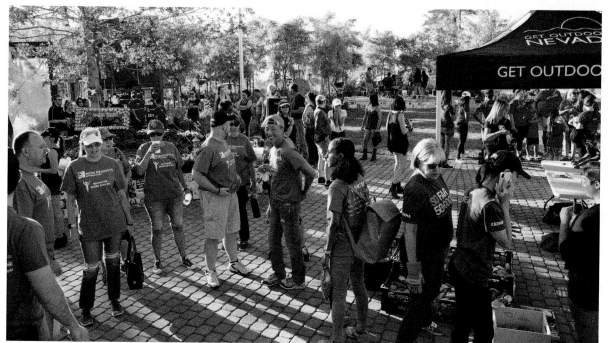

I don't think the country knew who we were, and I don't think they knew who our soul was, and I don't think anyone really understood what a tight-knit community Vegas is in every sense of the word.

—Corey Nyman, concert attendee, restaurateur

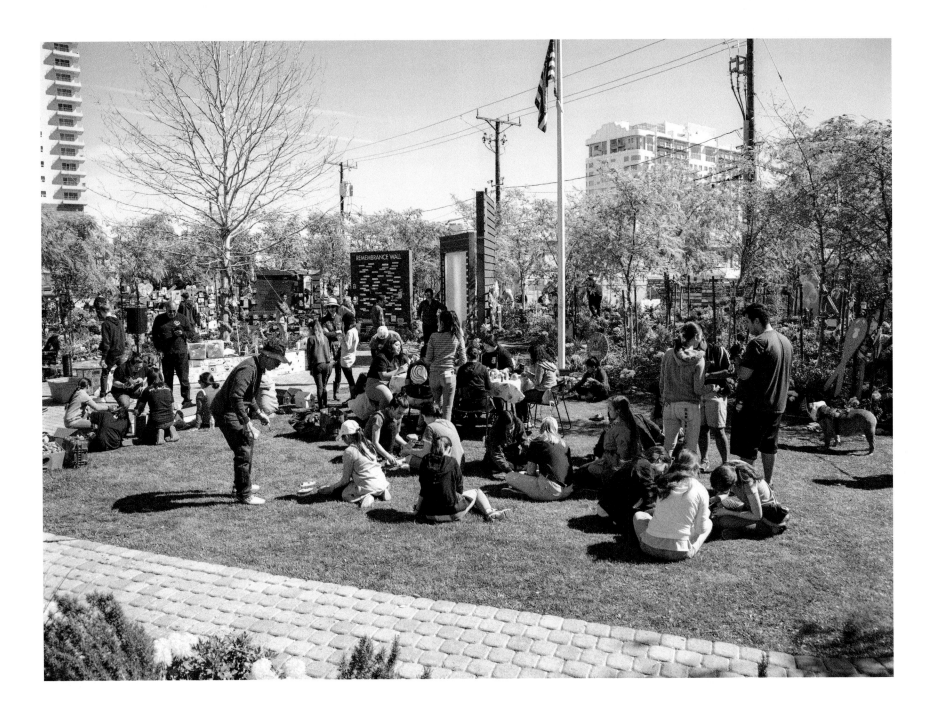

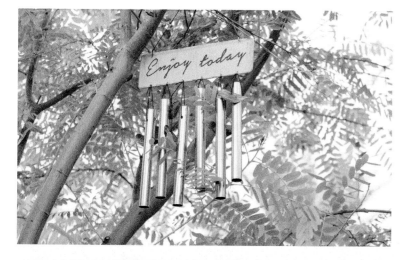

A thing of beauty is a joy for ever:
Its loveliness increases; it will never
Pass into nothingness; but still will keep
A bower quiet for us, and a sleep
Full of sweet dreams, and health,
 and quiet breathing.

—John Keats, from *Endymion*

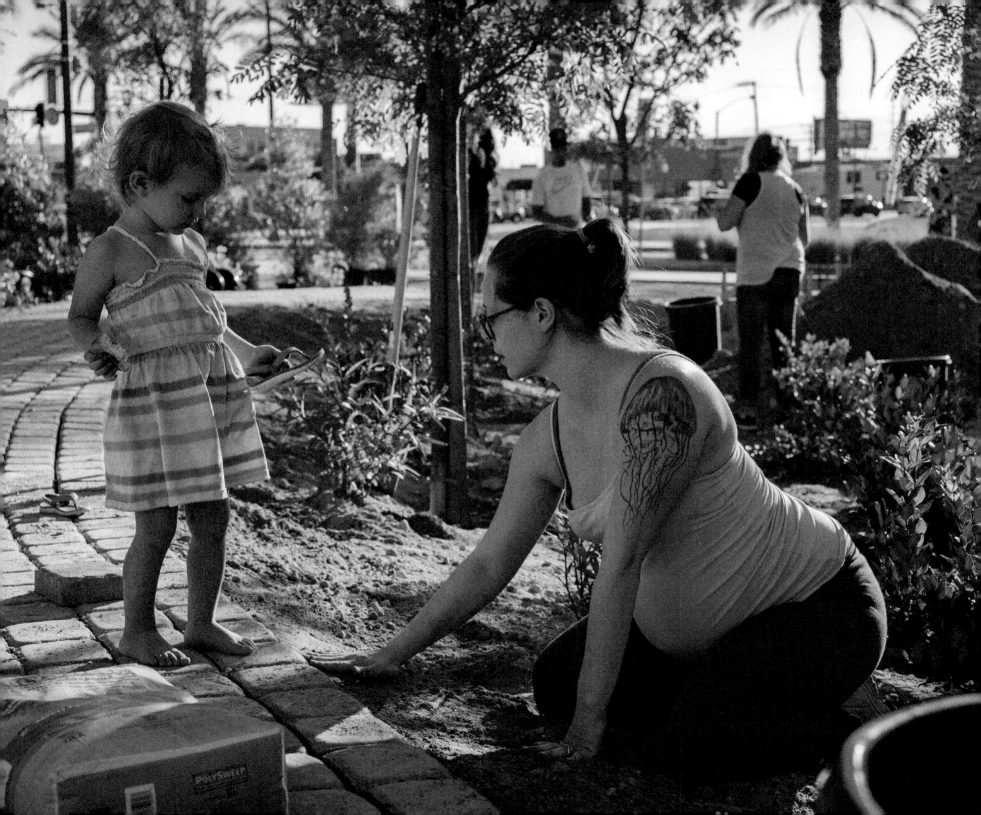

Life

We each lead a uniquely beautiful life, full of laughter, joys, tears, sorrow, growth, and experience. Our stories are for us to create and for those around us to continue to tell. Each story differs in length as some lives last 110 years and others end far too soon. Our stories are what keep us alive in the hearts and minds of everyone willing to listen. When tragedy struck in Las Vegas on 1 October, fifty-eight lives were cut short, but fifty-eight stories continued to live on.

At the Las Vegas Community Healing Garden, as we honor and celebrate with the world the lived lives of the fifty-eight victims, each continues to make an impact—a footprint—on our community and theirs. They continue to do good in the world, honored through parents, spouses, children, and friends. Their vibrancy, their youth, their smiles, their beings are forever intertwined amongst the blooming garden. Their stories grow with the trees and fill our lives with the color of the flowers.

The garden buzzes with life from the flitting of the hummingbirds,
the fluttering of the butterflies,
the music of wind chimes in the breeze,
and the rustling of the leaves
in the fifty-eight trees.

All of these tell the stories if you listen closely.
Each life is worth remembering; each story never forgotten; each life uniquely beautiful.

—Jessica Anderson,
director of community engagement,
Get Outdoors Nevada

My kids saw me when I walked in and gave my wife a hug. My oldest said, "Abba—father, dad— why are you crying?" I just hugged my kids. We sat them down and I just said to them, "There was a bad person who hurt a lot of people." It was tough. That was one of the hardest things I remember as a parent—as a parent [who is a] police officer—telling my kids that something had happened. I mean, they're naive; they're kids. I just felt that as best as I could [I had] to explain to them what had happened. It was incredibly difficult, but I'm glad we did it. . . . Five minutes later, they're like, "All right, can we go back in the backyard and play?" That's how it should be.

—Sergeant Steve Riback,
Las Vegas Metropolitan Police Department

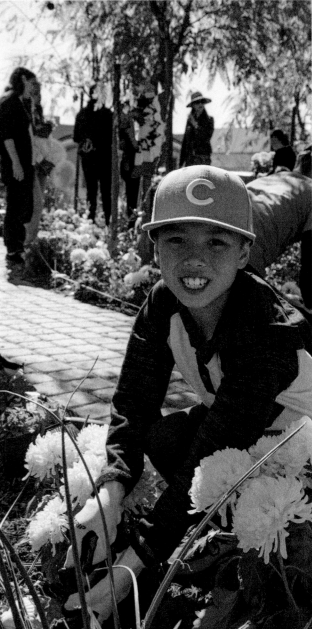

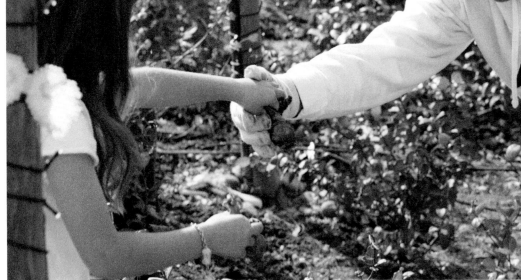

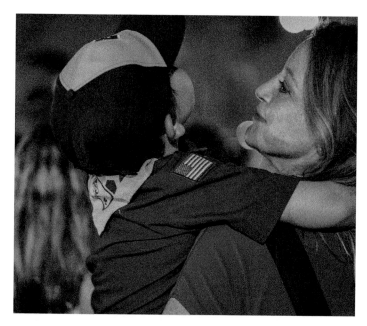

I went [to the Healing Garden] . . . It was this outpouring of the community—school buses. There were children out there. There were mothers carrying little babies. . . . There were people that were from, I think, nurseries and companies. Just everyone was out there, and they knew they had a goal. It's like, *we're going to get this done.* That night I took my son and we went to the opening.

—Tanya Olson, filmmaker

Cirque du Soleil . . . went dark Monday night after it happened and resumed on Tuesday. What people don't know is Cirque du Soleil gave us almost 200 tickets for our Red Cross workers to come to escape what they were working with for ninety minutes.

—Charles Scott Emerson, executive director, Southern Nevada chapter, American Red Cross

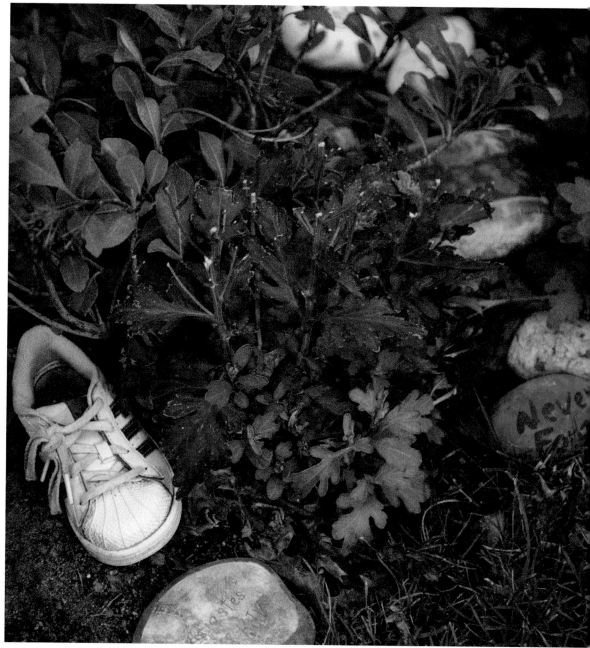

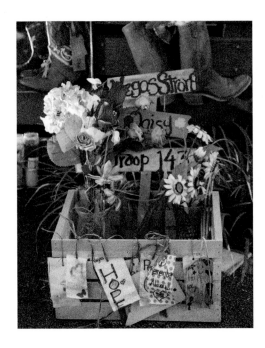

Two days after 1 October I got an email . . . from a high school student back East. . . . She said, "I and a few of my classmates figure your organization is probably really busy with 1 October, and we want to do something to help. Can we send thank-you cards to your volunteers?" . . . Something just touched me: *wow, someone clear across the country.* . . . When I got the box I broke down, because it was from Sandy Hook High School (Newtown, Connecticut). All the kids that participated were either at Sandy Hook Elementary School or had siblings that died [in the shooting].

— Jill Roberts, investigator, Clark County Coroner's Office; CEO, Trauma Intervention Program of Southern Nevada

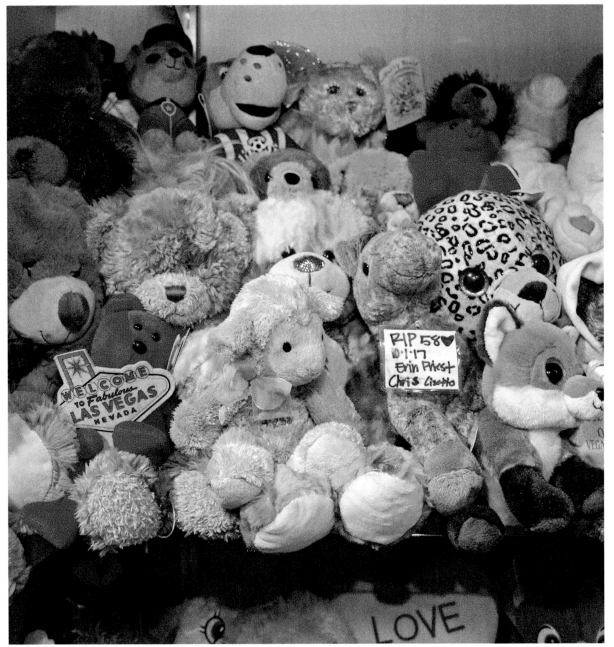

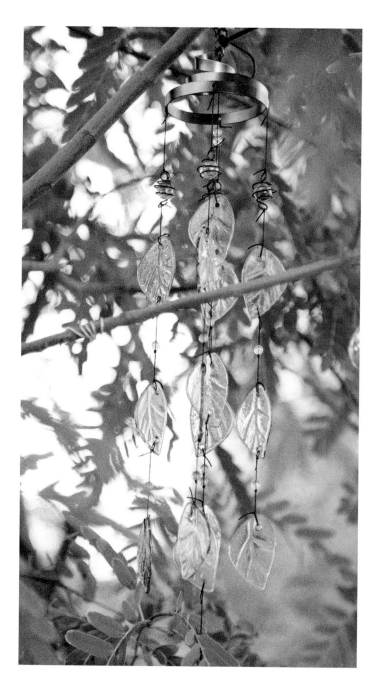

[The garden] exemplifies how even a small outdoor space in a very urban context can be incredibly important to people and how important that natural experience, like hearing the bird songs and seeing the trees, having some natural smells and sounds, like rustles of the leaves. It is really important, and it has a soothing effect on people.

—Mauricia Baca, executive director, Get Outdoors Nevada

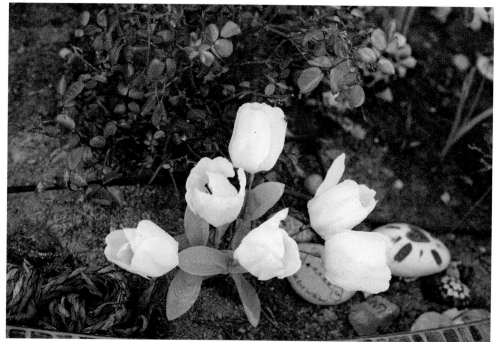

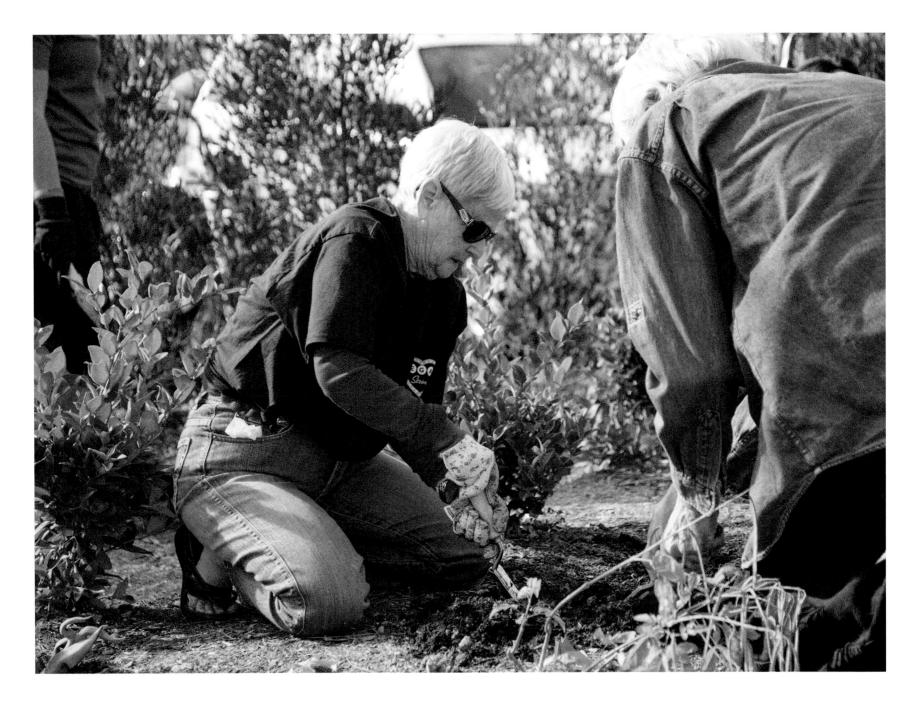

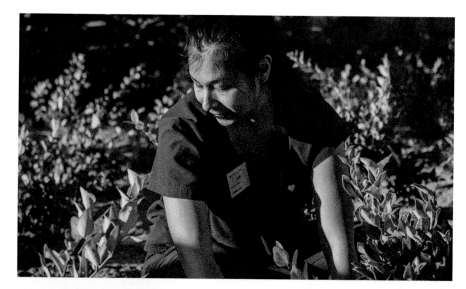

[People] who visit the garden . . . usually say how much life and movement is out there because of the wind chimes and windmills. You sit there for ten minutes, and you're going to see hummingbirds and butterflies and those kinds of things all year long. . . . There is all this life around you that's just growing.

—Jessica Anderson, director of community engagement, Get Outdoors Nevada

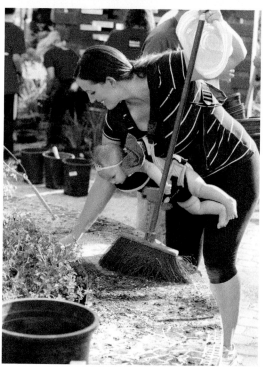

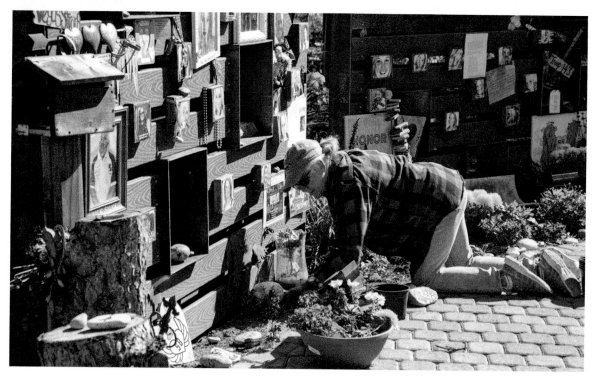

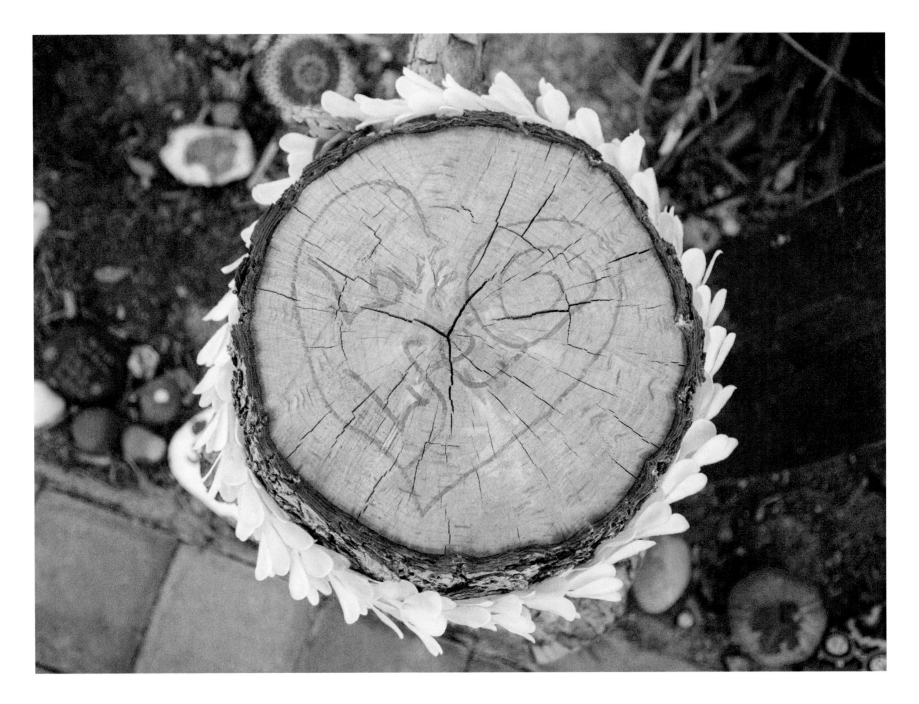

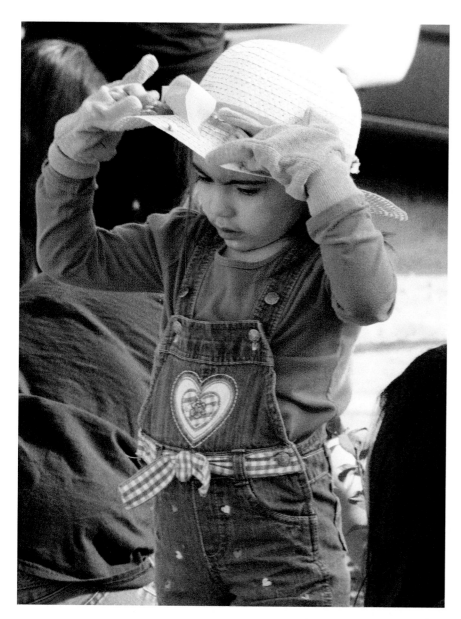

Wherever life plants you, bloom with grace.

—French Proverb

 Pursue the things you love doing, and then do them so well that people can't take their eyes off you.

—Maya Angelou from *I Know Why the Caged Bird Sings*

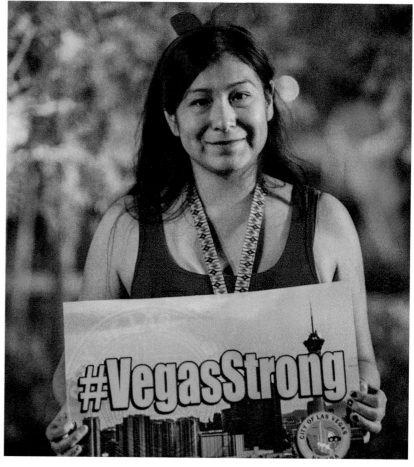

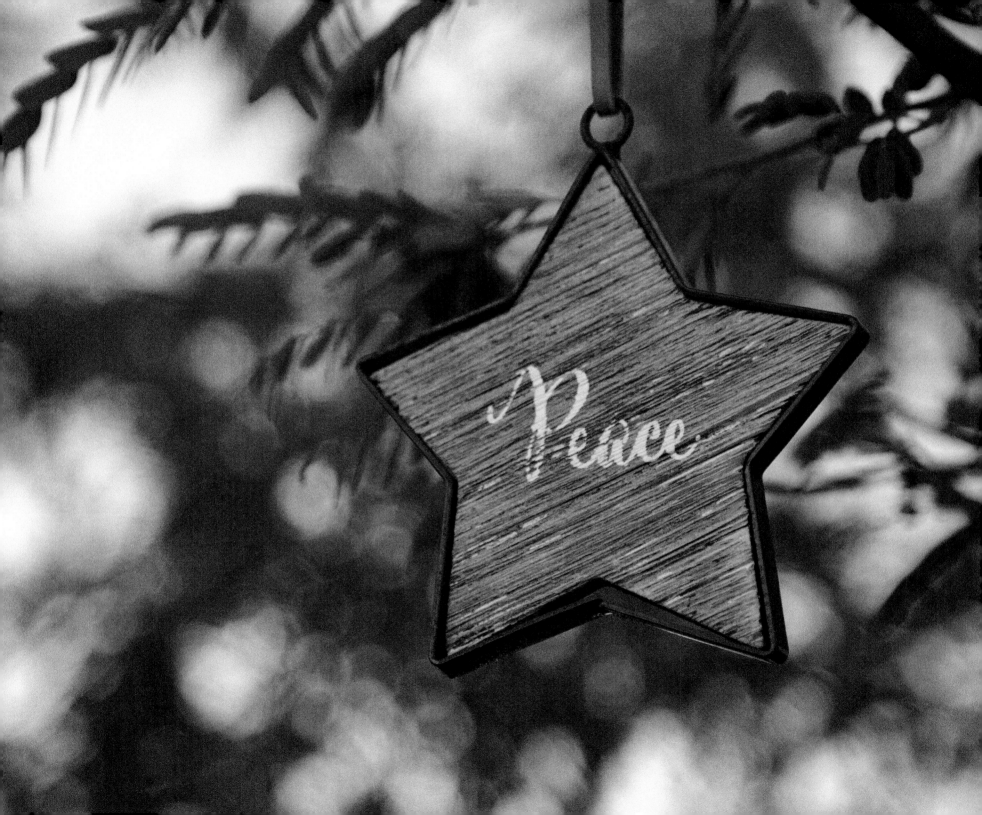

Peace

When we say we seek peace, find peace, bring peace, come in peace, or pray for peace, what "peace" do we mean?

If we seek it externally, lasting peace eludes us. We find ephemeral peace in the freshness of a bloom, the tranquility of a sunset, and the stillness of a virgin snowscape. These moments remind us of the power and promise of peace. But as blooms fade, suns set, and snow melts this peace dissipates if it is not continuously refreshed. This peace, once tasted, can inspire pursuit of a deeper peace.

When we aspire to achieve peace within, we strive for healing from daily stress or extraordinary trauma. When we reach within, we pursue a peace we can drink from endlessly to remain in balance. Reaching peace of heart and mind takes time. It is a lifelong journey—moment by moment, day by day, and year by year—to keep life and surroundings simple so we may hear and heed the quiet.

Why do poets and philosophers exalt peace from within but struggle to define it? Under the best circumstances, sharing one's inner peace begets a sense of brotherhood and understanding that generates and nurtures peace within others. Inner peace—the peace that heals the pain, touches the soul, and replenishes the spirit—is an aspiration. It takes work. It takes time. It takes dedication. But the reward can be life changing.

—Stefani Evans, oral historian,
Oral History Research Center,
UNLV Libraries

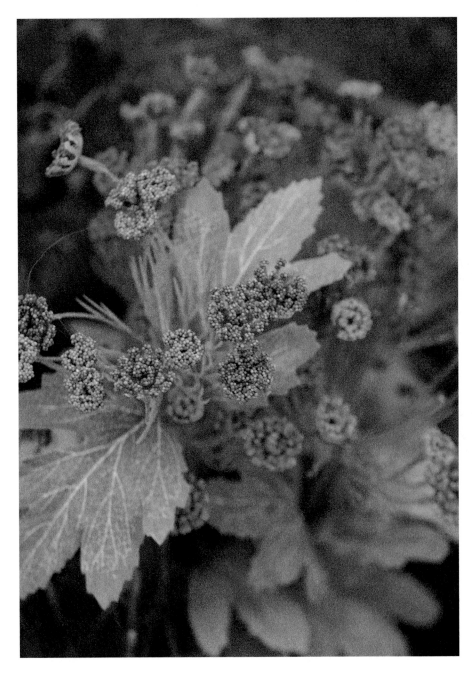

I didn't know that what I do could be used to help improve a space for people that are in pain, for people that are hurting. Sometimes when you go through these crises, the colors, the carpet, the finishes, that's the last thing anybody thinks of. . . . The end result would be for those people to do better, for those people to heal.

—Aracely Rascon, designer, Vegas Strong Resiliency Center

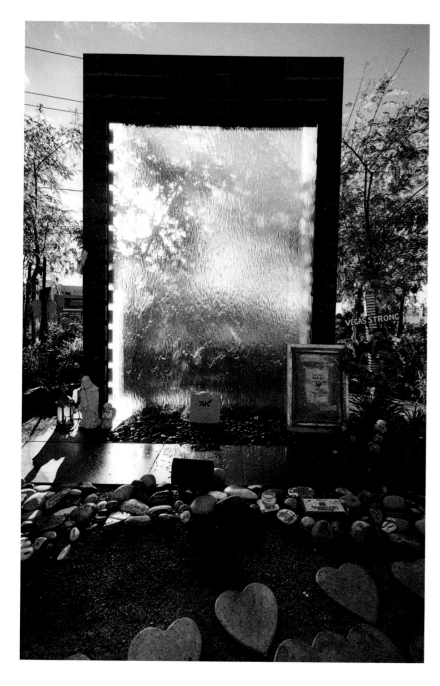

It is just this huge water wall, and it's beautiful. You can kind of see through it, but kind of can't see through it. You take whatever . . . belief system you have into seeing through to the other side. For me, it's just more movement. It is never just quiet there, and I think that's really important, because it's not meant to be.

—Jessica Anderson, director of community engagement, Get Outdoors Nevada

[The Healing Garden] is a place that is permanent . . . that they know is going to be here year after year. If they're having a bad day . . . they can just come and feel peace.

—Jessica Anderson, director of community engagement, Get Outdoors Nevada

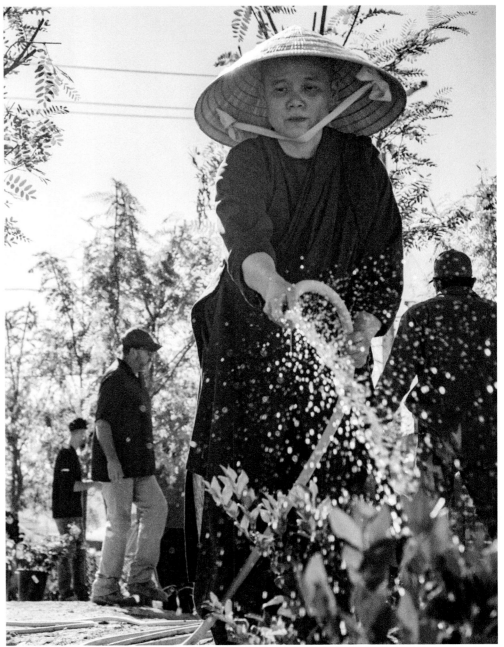

We are a strong community. We are a small-knit community. We're a community with incredibly deep roots and identity.... We're big and we're little all at the same time. People see only the big. They see only the billboards.... Yes, we're *that*. But we're so much more; we're *this*. We've all known we're *this*. Let us share this with you, but let us share it with each other in this moment in time, too.

—Joy Rineer, architect;
supplier, Vegas Strong Resiliency Center

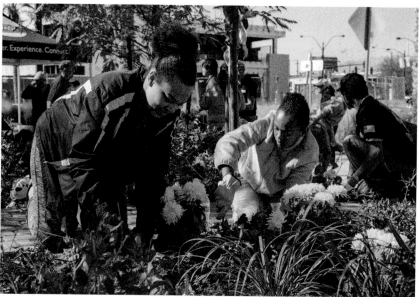

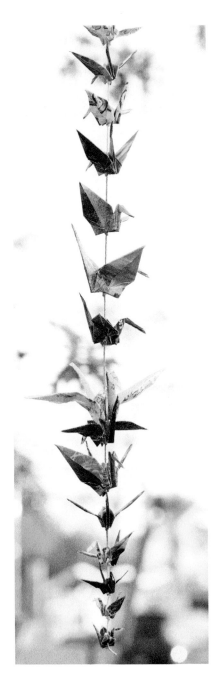

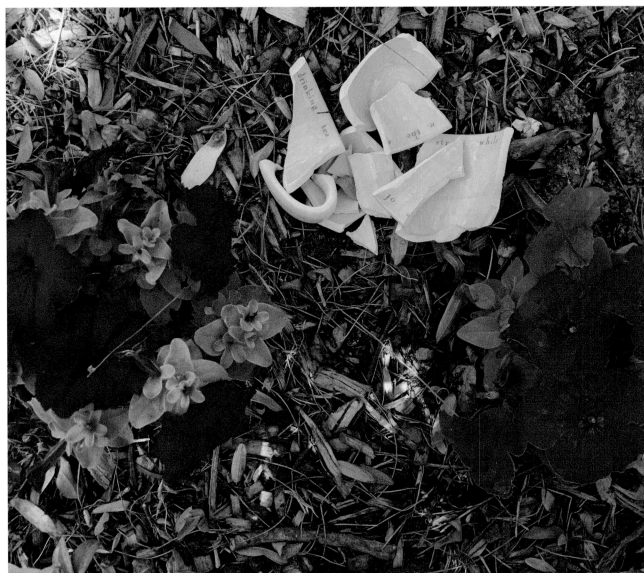

Right now I'm a teacup broken into pieces. I'm gluing my pieces together. Will I ever be the same teacup? No, I'm modified. I'm discovering a lot of things about myself. I'm paying more attention.

—Maria Paloma Galvan, rescue driver, artist

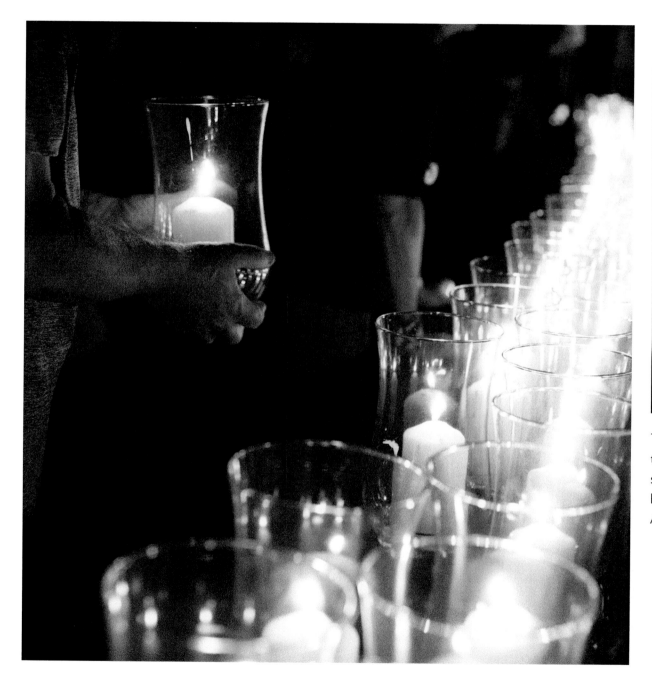

The community, we are healing. It will take a long time... There will always be a scar. There will always be a scar, always, here. [But] we're human beings and we're Americans and we're resilient. We are.

—Alan Stock, radio talk show host

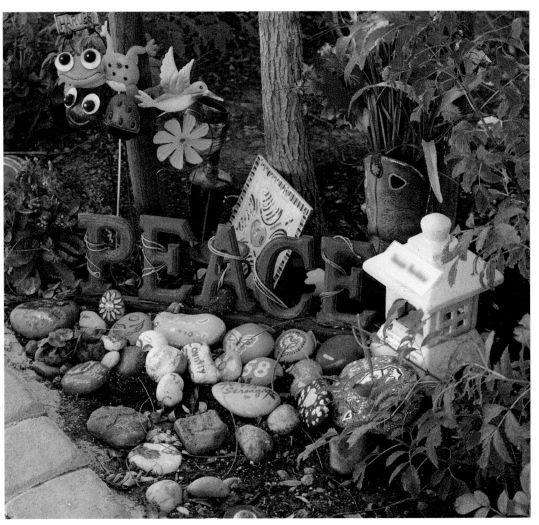

As survivors would come, they would be sobbing. If they were sobbing, I would say, "Are you okay?" Then I would tell them my story, and they would tell me theirs. Fifteen minutes would go by, and both of our hearts had healed. There were so many of those each day that I almost started to look forward to that. I'm going to go down, and I'm going to find someone, and they're going to need me maybe as much as I need them. But maybe today they just need me, and maybe the next day I would meet someone that I needed. —Chris Davis, bereaved father

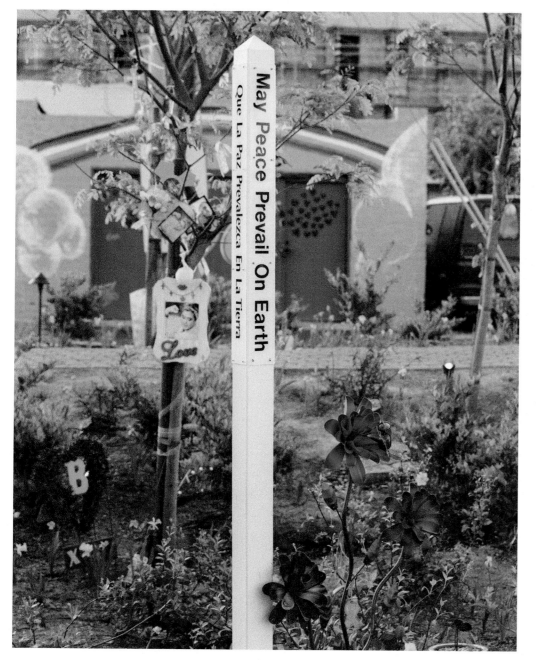

If you don't allow people to give, they can't heal, either. We learned saying "no" to people wasn't a kind thing. We had to accept. It was hard, because you get to that point you don't feel like you're worthy.

—Mynda Smith, bereaved sister

Let there be peace on earth

And let it begin with me;

Let there be peace on earth

The peace that was meant to be.

With God as our father

Brothers all are we,

Let me walk with my brother

In perfect harmony.

Let peace begin with me,

Let this be the moment now;

With every step I take,

Let this be my solemn vow:

To take each moment

And live each moment

In peace eternally.

Let there be peace on earth

And let it begin with me.

—Songwriters Jill Jackson, Sy Miller,
Copyright 1955, 1983 by Jan-Lee Music,
ASCAP International copyright secured.
All rights reserved.

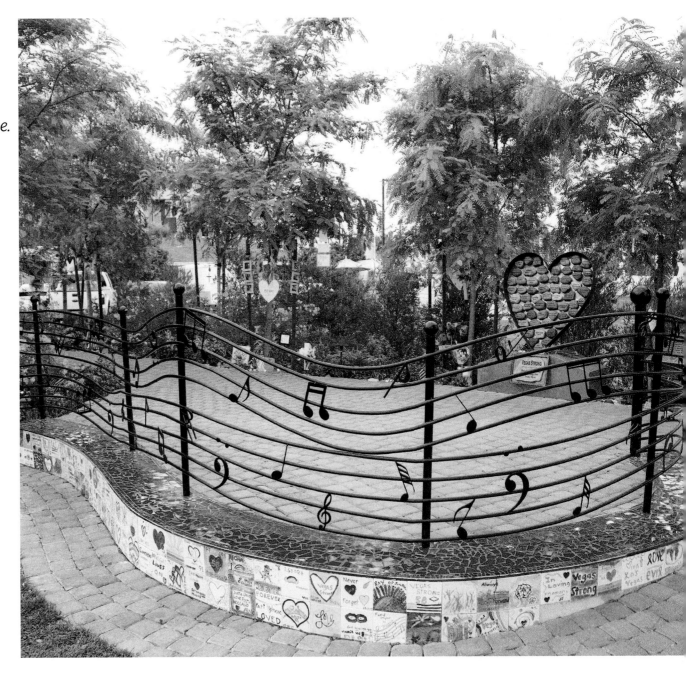

Music is the language of the spirit. It opens the secret of life bringing peace, abolishing strife.

—Kahlil Gibran, writer and poet

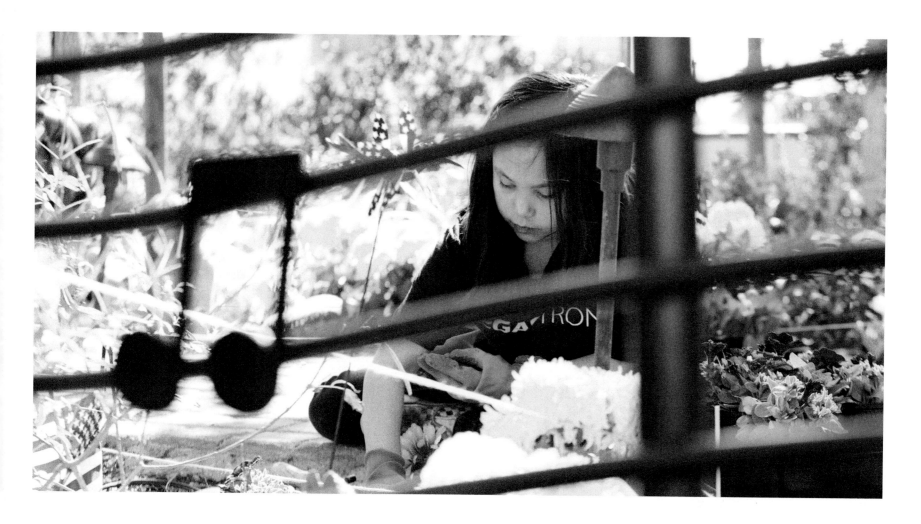

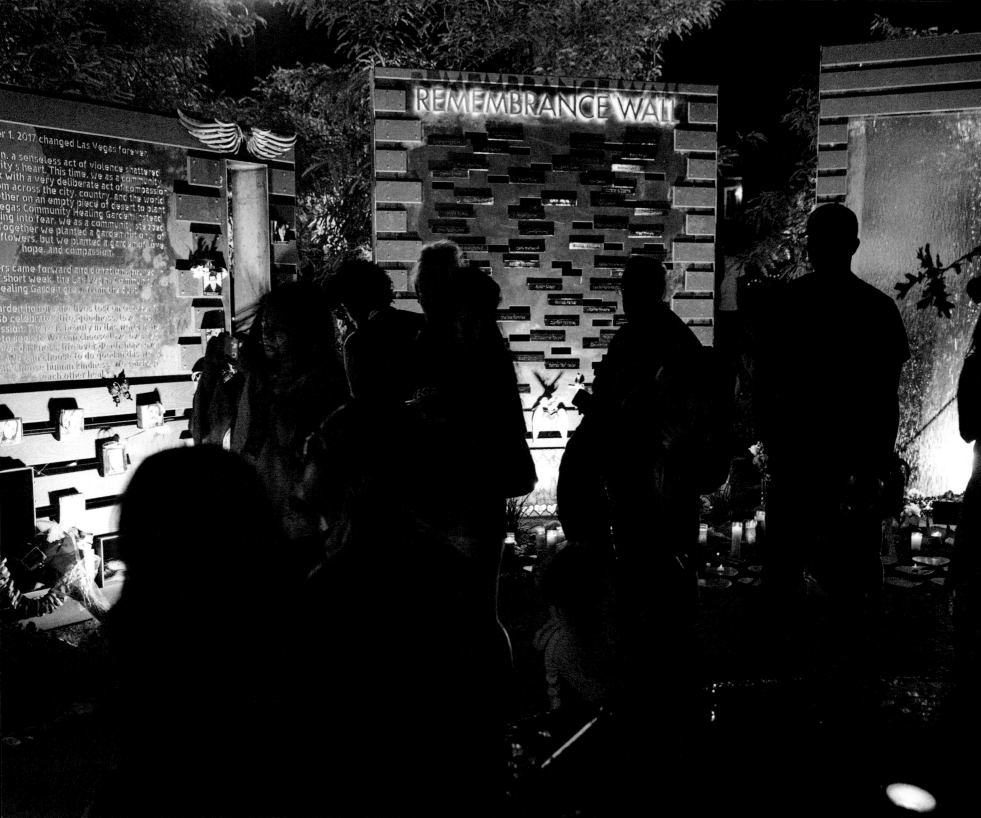

Epilogue

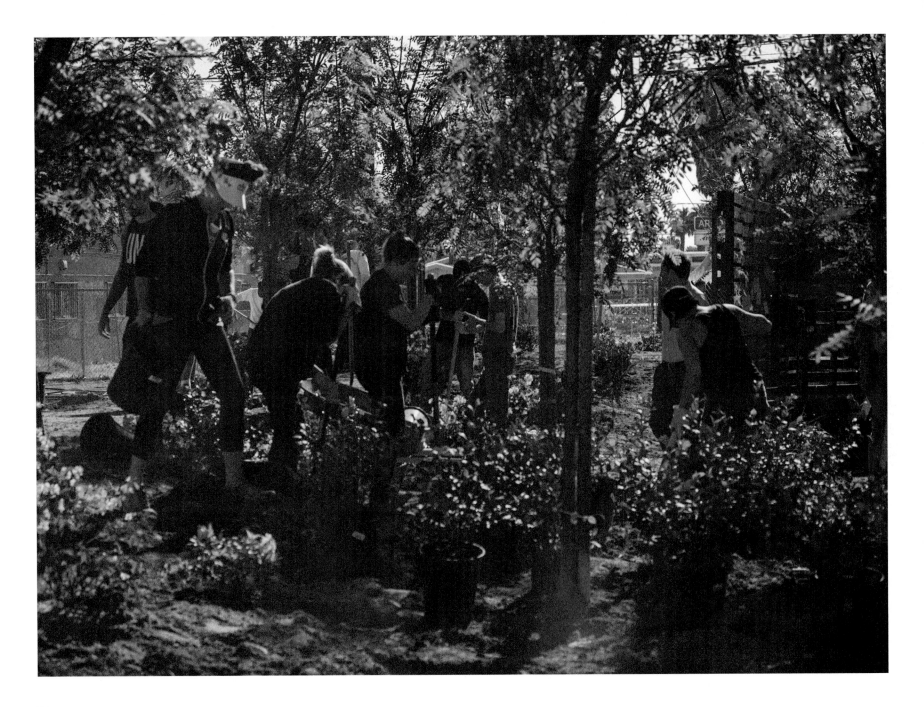

Plant a Tree

He who plants a tree
 Plants a hope.
 Rootlets up through fibres blindly grope;
Leaves unfold into horizons free.
 So man's life must climb
 From the clods of time
 Unto heavens sublime.
Canst thou prophesy, thou little tree,
What the glory of thy boughs shall be?
He who plants a tree
 Plants a joy;
 Plants a comfort that will never cloy;
Every day a fresh reality,
 Beautiful and strong,
 To whose shelter throng
 Creatures blithe with song.
If thou couldst but know, thou happy tree,
Of the bliss that shall inhabit thee!
He who plants a tree,—
 He plants peace.
 Under its green curtains jargons cease.
Leaf and zephyr murmur soothingly;
 Shadows soft with sleep
 Down tired eyelids creep,
 Balm of slumber deep.

Never hast thou dreamed, thou blessed tree,
Of the benediction thou shalt be.
He who plants a tree,—
 He plants youth;
 Vigor won for centuries in sooth;
Life of time, that hints eternity!
 Boughs their strength uprear;
 New shoots, every year,
 On old growths appear;
Thou shalt teach the ages, sturdy tree,
Youth of soul is immortality.
He who plants a tree,—
 He plants love,
 Tents of coolness spreading out above
Wayfarers he may not live to see.
 Gifts that grow are best;
 Hands that bless are blest;
 Plant! life does the rest!
Heaven and earth help him who plants a tree,
And his work its own reward shall be.

— Lucy Larcom

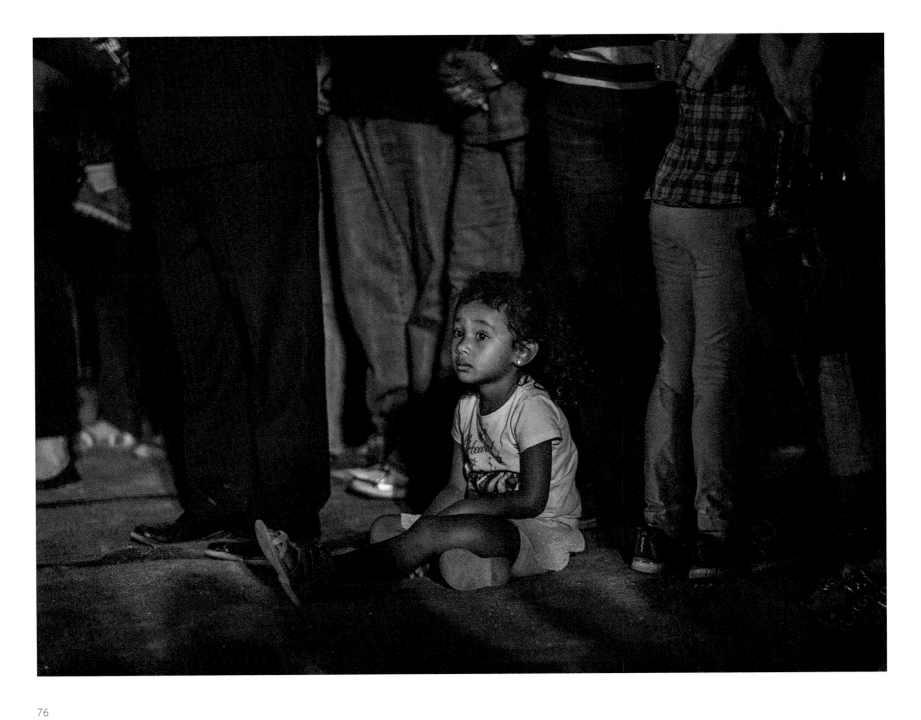

Helping Children Deal With Trauma

Michelle Paul and Carolina Meza Perez

Trauma comes in various forms—and, so do reactions to a trauma. What one child experiences as traumatic may not be what another child experiences as traumatic. And a child's response to a trauma will depend on many factors such as their developmental level. For example, the effect of a traumatic event on a child in elementary school is more dependent on their parent's or caregiver's reaction than the effect of a similar event on a teen in high school. Still, there are common themes to keep in mind when looking to support a child or adolescent after a traumatic experience:

Safety and Sameness:

- Be present and available. Act in ways that reassure the child that you and other trusted adults (e.g., teachers, coaches, pastors) will remain present and available to protect them.
- Reassure your children that you will make their safety a priority. Talk to your children about their safety concerns and help them develop plans for when they feel unsafe.
- Maintain consistency. The more things stay the same, the more children feel safe and secure. Keep up rules, expectations, and routines (including the fun ones).
- Show and express love, support, and optimism (i.e., hugs, kisses, encouraging words).
- Identify and connect with trusted friends, neighbors, and loved ones. As Mr. Rogers said, "Look for the helpers."

Validate and Engage in Healthy Coping

- Make time to be together and allow space for any questions, thoughts, and feelings that come up. Remember that it's okay to feel what we feel. And it's okay to say that we don't know the answers.
- Avoid discussing upsetting topics before bedtime or forcing children to speak. It's a common *misconception* that people must talk about their traumatic experiences in detail as soon as possible to heal. To the contrary, people need to feel safe to share as little or as much information on the timeline that works for them.
- Normalize and identify the full range of feelings that may show up. Allow them for your child. Allow them for yourself.
- Talk about and model healthy coping (write in a journal, spend time with others, cry together, call a friend, admit that we may have overreacted).

Soothing and Self-Care

- Remind your child to take care of themselves by drinking water, eating regularly, resting, and engaging in fun distractions (exercise, watching a funny movie, or having a special snack). This goes for grown-ups, too.
- Limit media (TV, social apps) to avoid misinformation or re-exposure to upsetting information.
- Manage reminders (people, places, sounds, smells, feelings) and clarify the difference between the event and the reminders of the event.

If after a couple of months, you don't see improvement in your or your child's suffering, seek professional help. Mental and behavioral health professionals are well-equipped to assist you and your child move through the pain to a brighter future.

References

Cohen, J. A., A. P. Mannarino, and E. Deblinger (2017). *Treating Trauma and Traumatic Grief in Children and Adolescents (2nd ed.)*. New York, NY: The Guilford Press.

National Child Traumatic Stress Network (2017). *Parent Guidelines for Helping Youth After Mass Violence Attack*. Retrieved from: https://www.nctsn.org/sites/default/files/resources//parent_guidelines_helping_youth_after_mass_violence_attack.pdf

MICHELLE PAUL, PhD, is an associate professor in residence, associate director of clinical training–psychology, and clinical director of The PRACTICE: A UNLV Community Mental Health Clinic, University of Nevada, Las Vegas.

CAROLINA MEZA PEREZ, PsyD, is a post-doctoral scholar at The PRACTICE: A UNLV Community Mental Health Clinic, University of Nevada, Las Vegas.

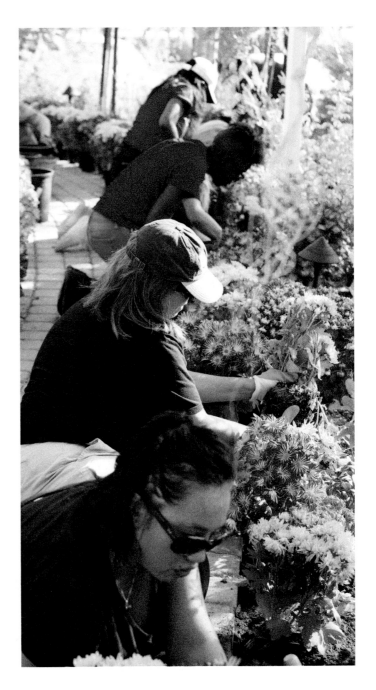

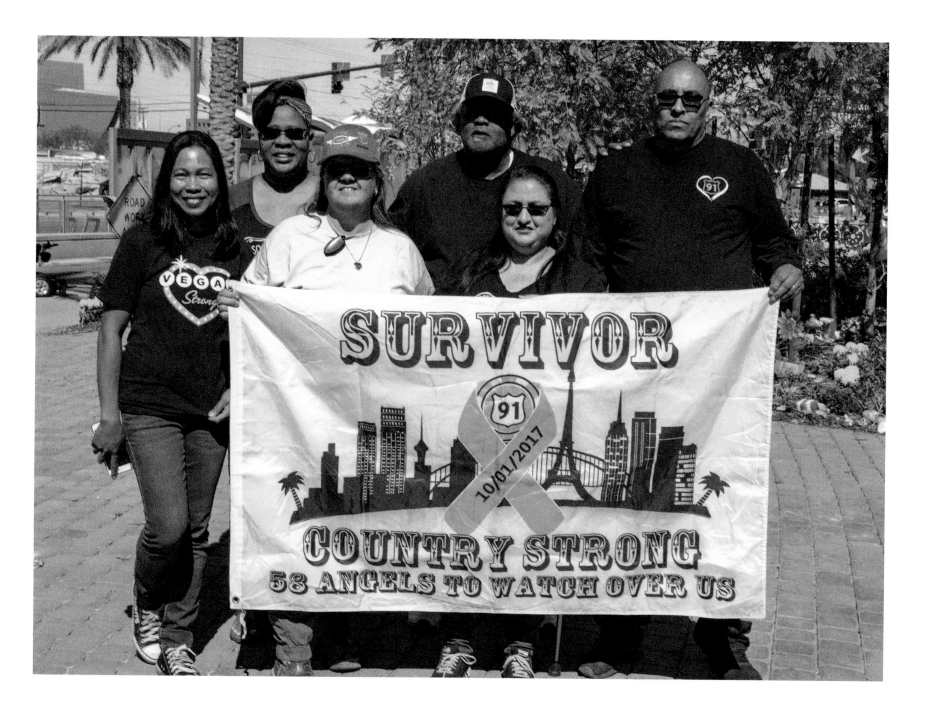

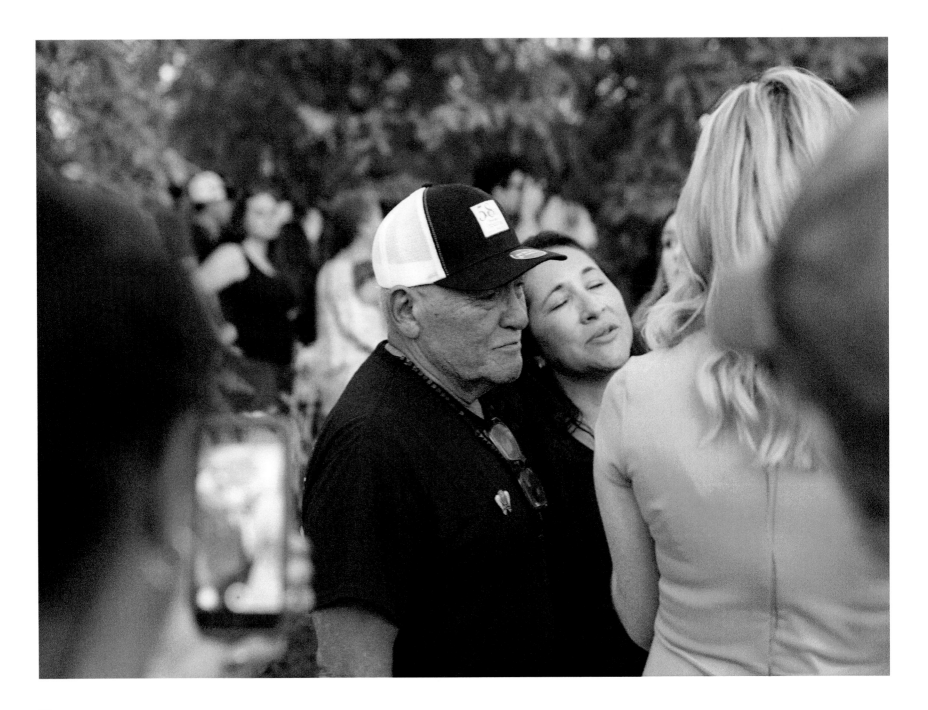

Dealing With Trauma as an Adult

Carlton Craig

Nearly 60 percent of Americans will experience a trauma in their lifetime; yet, less than 10 percent go on to develop what we know as lifetime Post-Traumatic Stress Disorder (PTSD). These percentages are higher for some more at-risk populations such as survivors of sexual assault and combat veterans, according to Harvard epidemiologist Ronald C. Kessler and colleagues. A number of coping responses are available if a person is exposed to actual or threatened death, serious injury, or sexual violence by directly experiencing the traumatic event, witnessing in person the event(s) as it occurred to others, or learning that the traumatic event occurred to a close family member or close friend, and/or if a loved one dies from a violent or accidental death.

First, one need not immediately realize they have PTSD. Symptoms of PTSD must last at least thirty days and consist of highly intrusive symptoms (e.g., continuously rethinking about the event or flashing back to the event); avoidance of stimuli and reminders of the traumatic event (e.g., avoiding places, conversations, or people that remind one of the event); negative alterations in thoughts and moods associated with the traumatic event (e.g., persistent negative emotional state in terms of anger, guilt, horror, fear, or shame); and marked alteration of arousal and reactivity associated with the traumatic event (e.g., irritable behavior and angry outbursts). Also, Acute Stress Disorder (ASD) is a disorder with similar symptoms as PTSD that lasts three to thirty days. However, both the terms PTSD and ASD are reserved for people who are experiencing functional impairment in social or occupational settings, or other important areas of functioning. [According to the (Diagnostic and Statistical Manual of Mental Disorders (DSM-5; American Psychiatric Association, 2013)].

The following is a list of ways to cope with stress caused from a traumatic event.

- Maintain as normal a schedule as possible.
- Try to get good nutrition; avoid carbohydrate loading commonly found in comfort foods.
- Take time for yourself to engage in self-care (e.g., soothing baths, shopping, engaging hobbies/activities, playing with children) but *do not* isolate yourself.
- Engage your natural social support system (e.g., partners, family, friends).
- If you have a spiritual belief, engage it and use the support that the religious/spiritual community can provide (e.g., talking to a religious leader, close member of a congregation).
- Muscle massage therapy can help *unless* problems with touch make the problems worse.
- If the trauma resulted in the death of a loved one, *do not* grieve alone even if you feel like keeping it to yourself. Make sure you have at least one person you can talk to on a regular basis but preferably more than one.
- It is normal to be irritable after a trauma. If angry, count to ten and think before you speak.
- Stay active and exercise; start slowly if you have not exercised previously.

- Learn relaxation exercises and progressive muscle relaxation.
- Engage in mindfulness exercises, focusing on the here and now and listening but not responding to your thoughts. Also, learning meditation techniques can be helpful.
- If the thoughts and anxiety become too much, if all else fails, distract yourself (e.g., TV, hobby, any significant movement or activity).
- Do not increase alcohol use or recreational drug use; preferably try to cut down if you are engaged in these habits.
- If the symptoms persist and they are starting to impair your functioning at work, school, or in your personal care, or affecting you socially, then you should seek out a clinical social worker, counselor, clinical psychologist., or other licensed behavioral health clinician.
- Major depression is a common co-occurring disorder with PTSD, and you should be evaluated for it if your problems persist.
- If you need therapy, a number of evidence-based interventions (e.g., Prolonged Exposure Therapy, Trauma-Focused Cognitive Behavioral Therapy (TF-CBT), Eye Movement Desensitization and Reprocessing (EMDR), Cognitive Processing Therapy (CPT), Virtual Reality Exposure Therapy (VRET), Dialectical Behavioral Therapy (DBT), and Seeking Safety (for trouble with both PTSD and substance use) that have been recognized as helpful. In addition, evidence gathered in the past ten years indicates yoga can be useful as well.

References

American Psychiatric Association. (2013). *Diagnostic and Statistical Manual of Mental Disorders (5th edition)*. Arlington, VA: American Psychiatric Association.

Kessler, R. C., W. T. Chiu, O. Demler, and E. E. Walters (2005). "Prevalence, Severity, and Comorbidity of 12-Month DSM-IV Disorders in the National Comorbidity Survey Replication." *Archives of General Psychiatry*, 62, 617–627.

Kessler, R. C., K. A. McGonagle, S. Zhao, C. B. Nelson, M. Hughes, S. Eshleman, H. U. Wittchen, and K. S. Kendler (1994). "Lifetime and 12-month prevalence of *DSM-III-R* psychiatric disorders in the United States: results from the National Comorbidity Survey." *Archives of General Psychiatry*, 51, 8–19.

CARLTON D. CRAIG, PhD, LCSW, ACSW, DCSW, is director and professor in the School of Social Work at the University of Nevada, Las Vegas.

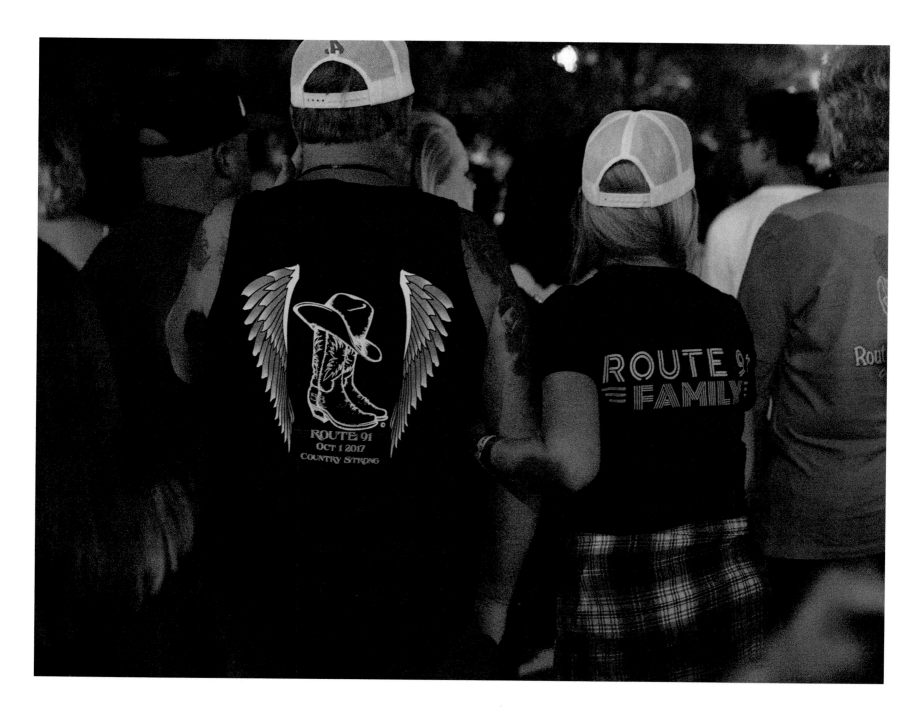

Getting Help (or volunteering)

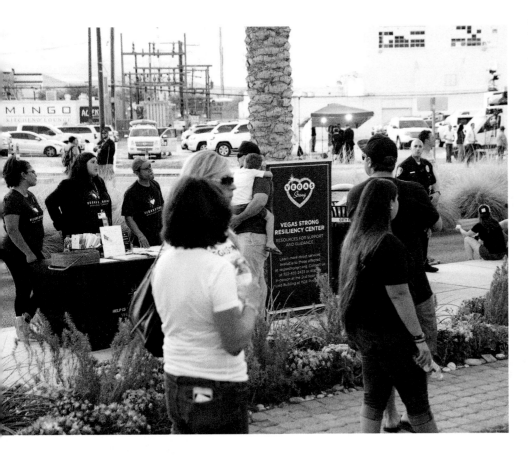

American Red Cross, Southern Nevada chapter
https://www.redcross.org/local/nevada/about-us/locations/Southern-Nevada.html

Center for Individual, Couple, and Family Counseling (at UNLV)
Provides quality, low-cost therapy to residents of the Las Vegas community
https://www.unlv.edu/cicfc

The PRACTICE (at UNLV)
Provides affordable, evidence-based mental health care
https://www.unlv.edu/thepractice

Trauma Intervention Program (TIP) of Southern Nevada, Inc.
Helps those who are emotionally traumatized in emergency situations receive the assistance they need.
Comprehensive Community Resource Guide
https://www.tipoflasvegas.org/crg
https://www.tipoflasvegas.org/

Vegas Strong Resiliency Center
Provides help for 1 October survivors affected by mass shooting events in the news
Call Disaster Distress Helpline, available 24/7: 1-800-985-5990
Call local number between 10 a.m. and 5 p.m., Monday-Friday:
702-455-2433
Text TalkWithUs to 66746
https://vegasstrongrc.org/

Curated by Miranda Barrie for UNLV Libraries.
Republished with permission.

City of Las Vegas ✔
@CityOfLasVegas

Here's info on how you can help further develop and maintain the Las Vegas Community Garden:

cityoflasvegas.tumblr.com/post/
166060277...

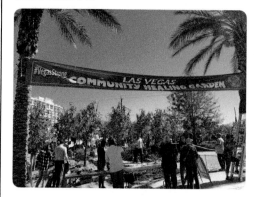

12:35 PM · 10/6/17 · Twitter for iPhone

Janna Karel ✔
@jannainprogress

Volunteers, many from @UNLV_SAE fraternity were out working at 8:00 this morning on the memorial garden in Las Vegas #vegasstong #RJnow

1:12 PM · 10/5/17 · Twitter for iPhone

Brett Anderson
@brettAnderson87

#Vegas: All hands on deck @ #LasVegasShooting Healing Garden. Need all the help w/ can get. Charleston & 3rd. #VegasStrong #Battleborn

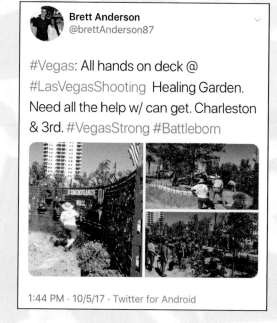

1:44 PM · 10/5/17 · Twitter for Android

Josh Lockwood
@JoshWLockwood

From Healing Garden in Las Vegas @Ozzypallooza @redcrossny @SNVredcross #VegasStrong

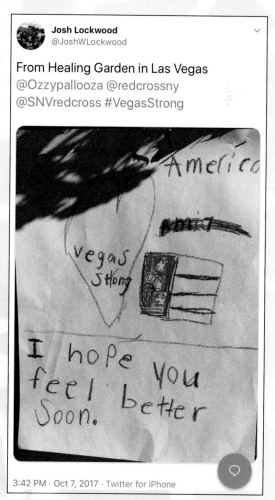

3:42 PM · Oct 7, 2017 · Twitter for iPhone

Acknowledgments

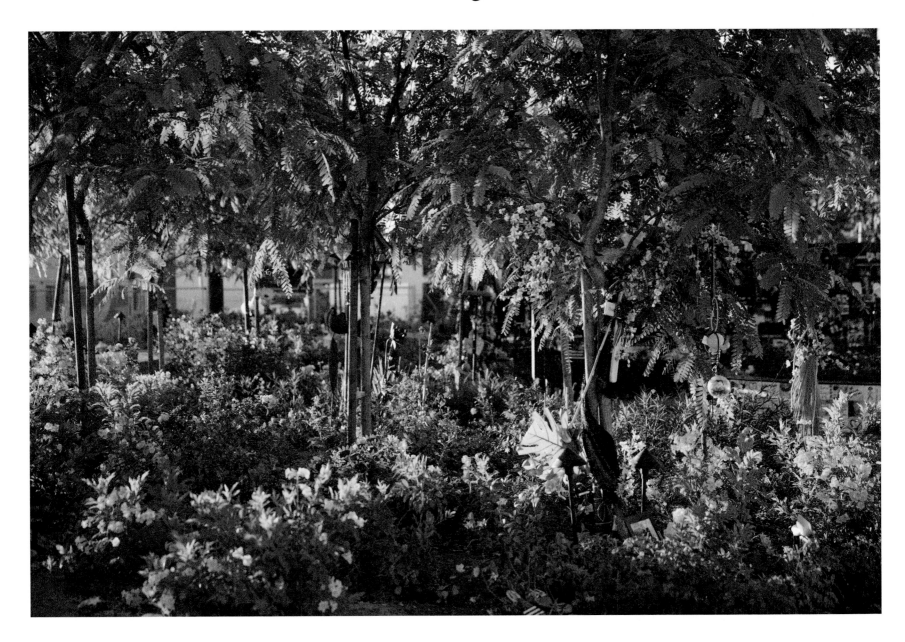

UNLV Oral History Research Center
UNLV University Libraries, Special Collections & Archives

It has been our honor to collect oral interviews and to curate quotes and photographs to support the healing of the city we love.

Stefani Evans, editor
Donna McAleer, editor
Barbara Tabach, interviewer
Claytee D. White, interviewer

We are grateful for the assistance of Suzan DiBella and Tamara Marino, UNLV Office of Community Engagement. We thank the incredible team at University of Nevada Press—Sylvan Baker, Alrica Goldstein, John McKercher, and Paul Szydelko—for lending their patience and expertise to this project.

Special thanks to
Maggie Farrell, dean of UNLV University Libraries, and Michelle Light, director of Special Collections & Archives, for encouraging this book to take root and blossom

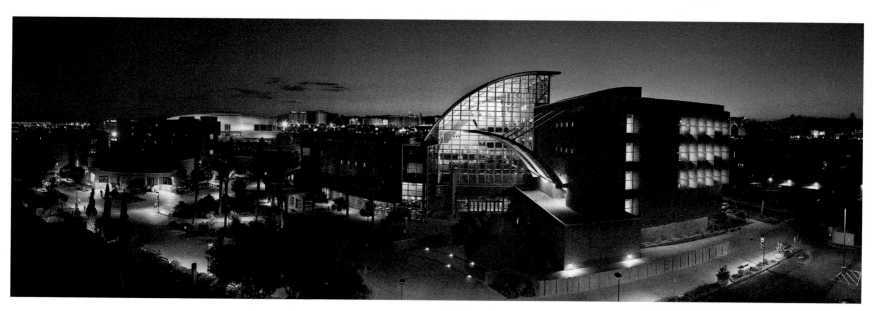

GET OUTDOORS
NEVADA is dedicated
to connecting people
of all backgrounds
and ages to Nevada's
diverse outdoor places
through education,
service, community
engagement, and
collaboration. We strive
to foster and support
a community that
discovers, experiences,
and connects to our
state's many natural
environments, from
wild landscapes and
recreational areas to
urban trails and parks.

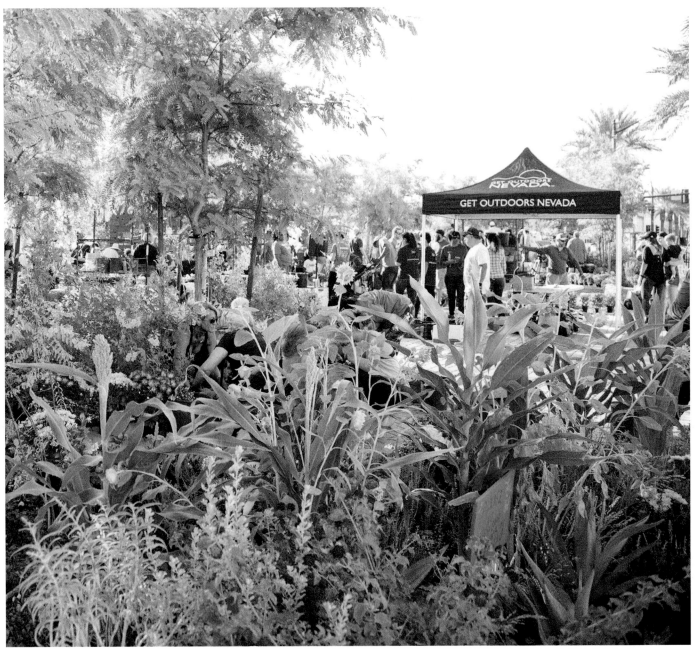

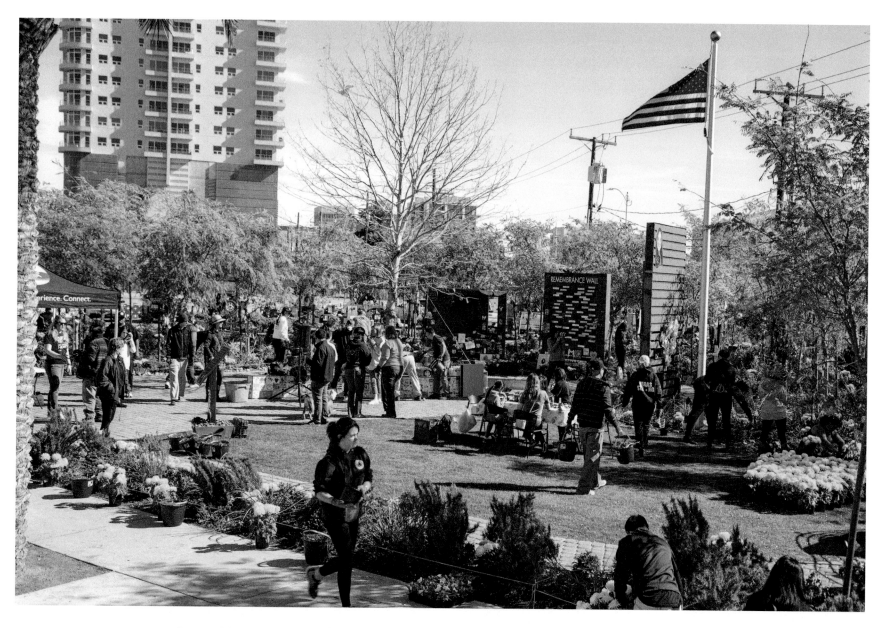

We would like to thank all those who shared their time, materials, and hearts with the Las Vegas Community Healing Garden. Your efforts have helped create and sustain a very special place. We could not be more grateful for all you have done.

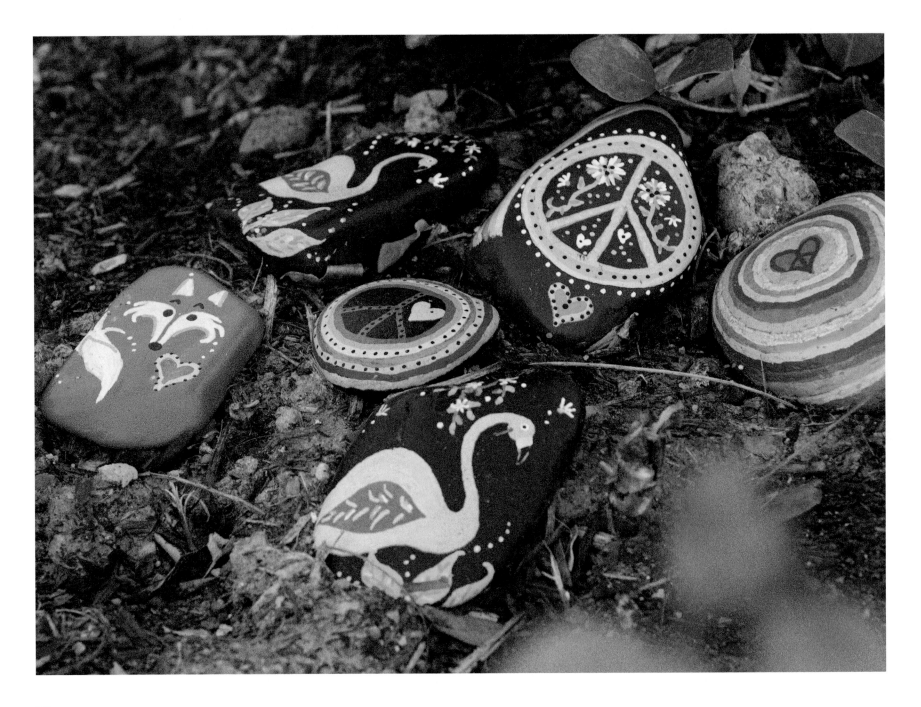

Photography credits

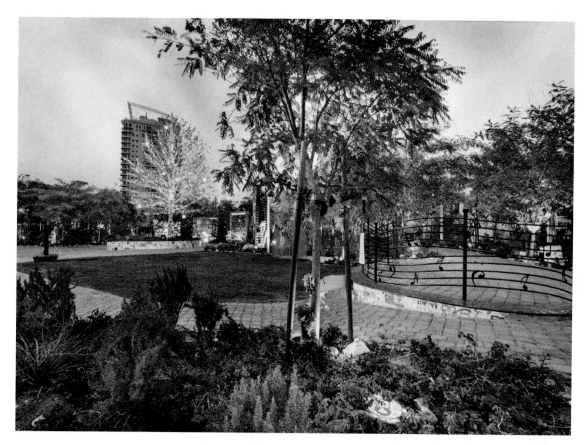

A special thank you to Jennifer Burkart and Ryan Reason, SquareShooting.com. They provided most of the images in this book, unless otherwise noted.

Other photographers' images appear as follows

Lauren Meredith Brown: 42 (right)
Stefani Evans: 37 (top left, right), 66 (right)
Alrica Goldstein: 3 (left), 9 and 85 (background)
Brad Jerbic: 14 (medallion insert)
Aaron Mayes: viii, 19 (left), 63, 87, 96
Tom Perrigo: 33 (right)
Shane Savanapridi, City of Las Vegas: 5, 8, 12, 13, 14 (rectangular images), 16 (left, bottom right), 18 (all), 19 (right), 22, 46 (both), 49 (bottom), 50, 53 (left), 57 (top), 59 (right), 64 (right), 74, 76, 83, 92
Malcolm Vuksich, Clark County Museum: 54 (right)

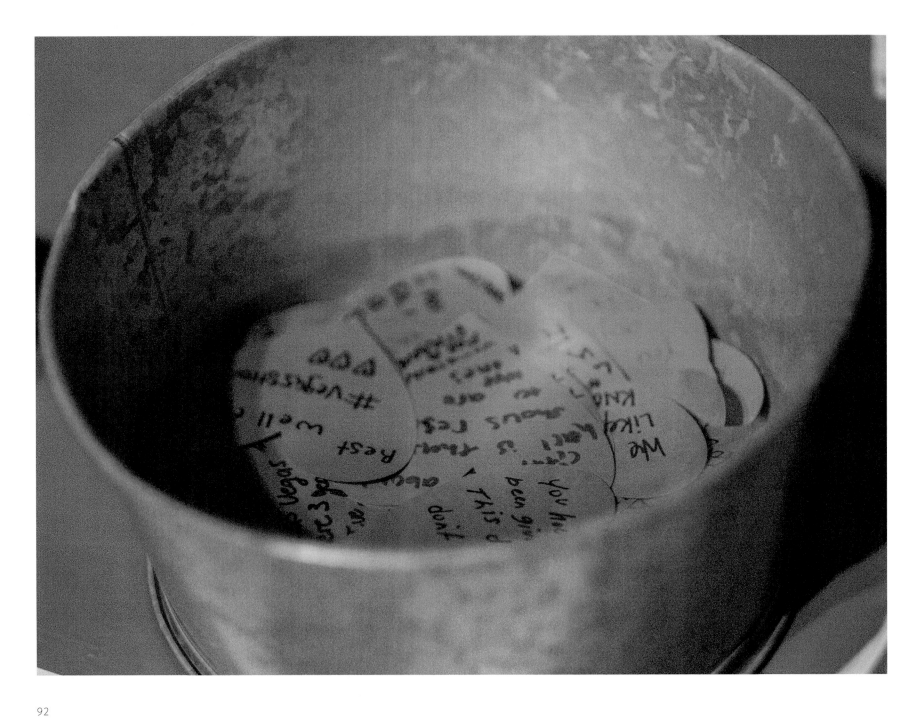

Message from the Mayor, City of Las Vegas, Carolyn Goodman

The year 2017 will always be marked in our consciousness by the horrific and tragic events of 1 October. Our city continues to heal and mourn all those we lost. Our hearts go out to the family members trying to make sense out of something that can never be fully explained or understood.

I remember being at University Medical Center the night of the shooting doing my best to comfort those who were afraid and who had suffered such loss. Even that night I started to notice the spirit and heart of our city rise up in response to this heinous act. First responders were out in force. The work of Sheriff Joe Lombardo and his team was extraordinary. Our nurses and doctors at the hospitals were incredible. Citizens were driving the wounded to the hospitals. As the days turned into weeks, we continued to see our citizens become everyday heroes offering help, comfort, and love to any and all who were in need. I knew that Las Vegas would not be defined by this act of hate because the spirit of our community would not allow it. We truly became Vegas Strong.

Today, that spirit lives on at the amazing Las Vegas Community Healing Garden. It was conceived, built, and opened in just five days. Two landscapers had the idea as they had coffee on October 2, 2017—and from that, a beautiful garden grew. They had hundreds of volunteers of all ages working together, shoulder to shoulder, putting any differences aside.

The Las Vegas Community Healing Garden is a place of peace in our city, a place of warmth and remembrance. I want to thank Get Outdoors Nevada for taking on the management of the garden for this city, so this location will be preserved for years to come.

The garden is a monument to not only those we lost, but also to the kind of community Las Vegas is and should always strive to be.

Las Vegas Mayor Carolyn Goodman with Tom Perrigo, executive director of community development.

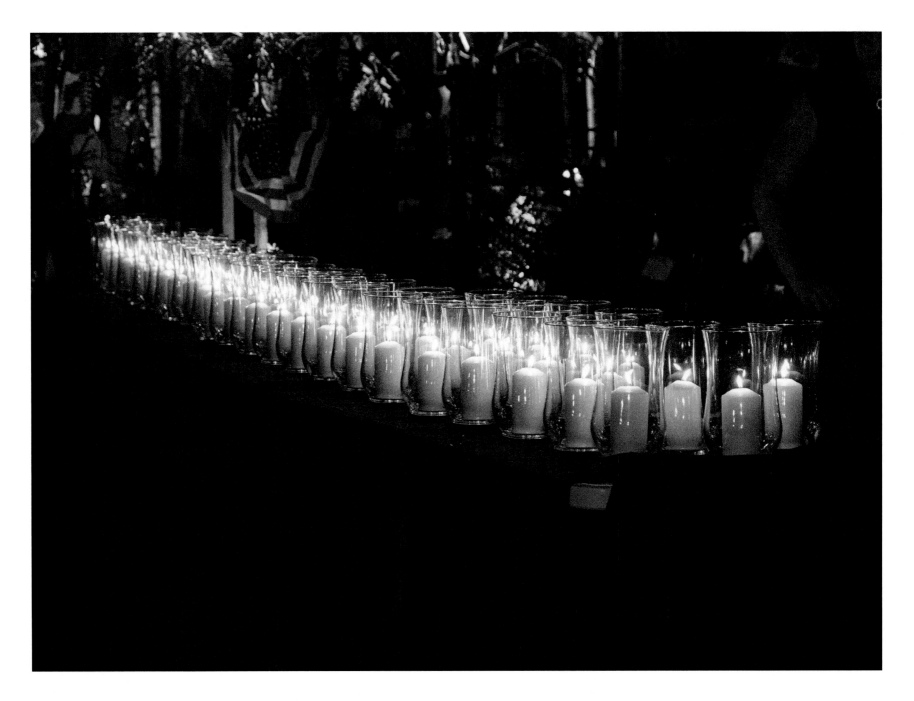

Message from the Governor, State of Nevada, Steve Sisolak

I'll never forget driving down to the scene of one of the most horrific mass shootings in our nation's history the night of October 1, 2017. I still clearly remember the sound of hundreds of cell phones, abandoned by their owners, ringing from loved ones checking in. That night exposed the darkest side of humanity and brought tragedy on fifty-eight families. It also brought out the best in our community—the community of Las Vegas—with countless people standing in line for hours to donate blood, giving millions of dollars to the victims' fund, and building the beautiful Las Vegas Community Healing Garden to remember the victims and provide space for the community to heal. I've never been more proud of the Las Vegas community for coming together in a tremendous show of strength, unity, and love in one of the darkest times Las Vegas has seen, and in the years of hope and healing since.

Governor Steve Sisolak (then chair, Clark County Commission)
with Mayor Carolyn Goodman and
U.S. Representative (now U.S. Senator) Jacky Rosen

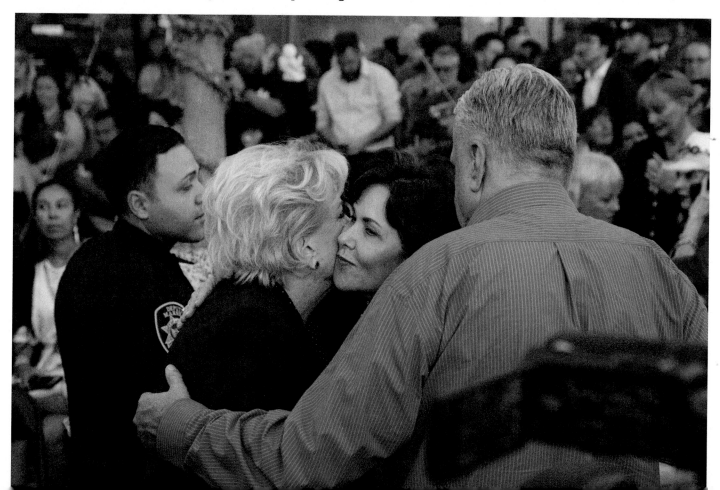

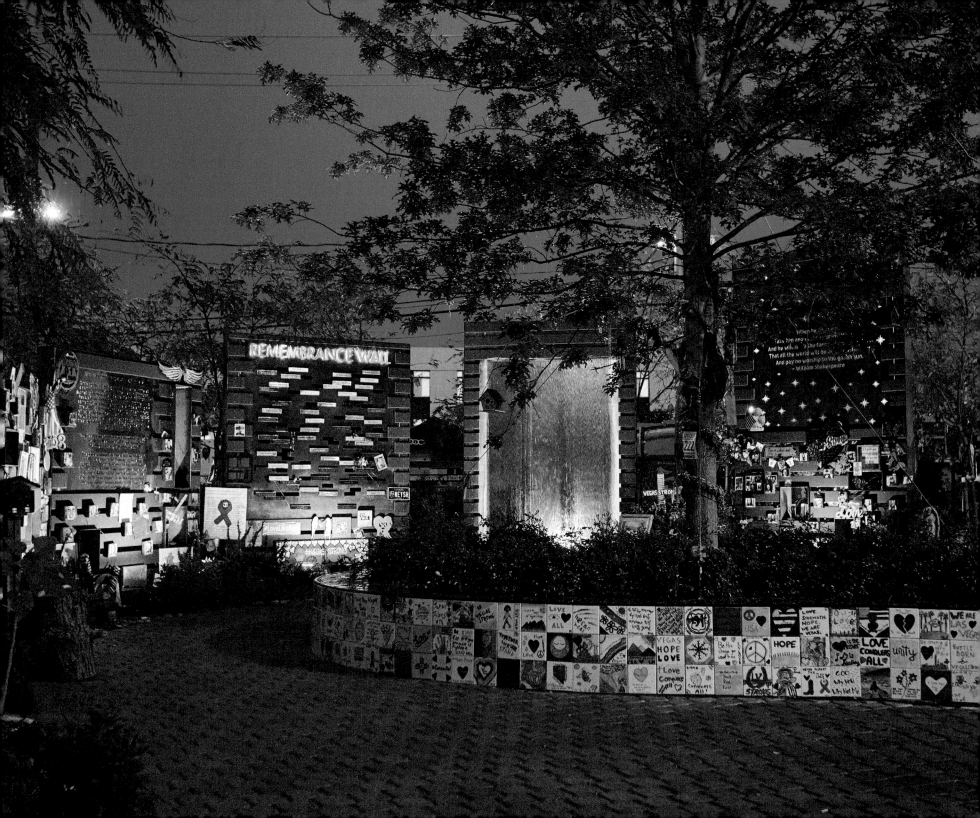